TESTING THE WATER

Young people and galleries

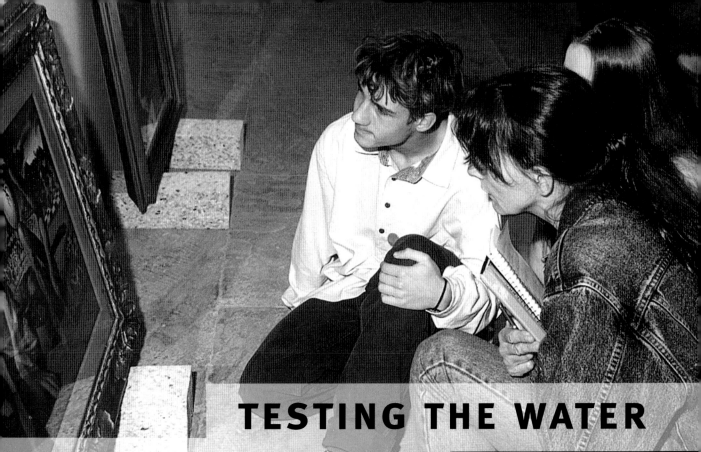

TESTING THE WATER

Young people and galleries

EDITOR:

Naomi Horlock

CONTRIBUTORS:

David Anderson

Lewis Biggs

Eilean Hooper-Greenhill

Toby Jackson

Ullrich Kockel

Gaby Porter

Sara Selwood

LIVERPOOL UNIVERSITY PRESS & TATE GALLERY LIVERPOOL

First published 2000 by

Liverpool University Press

4 Cambridge Street

Liverpool

L69 7ZU

and

Tate Gallery Liverpool

Albert Dock

Liverpool

L3 4BB

British Library Cataloguing-in-Publication Data
A British Library CIP Record is available

ISBN 0-85323-904-5

Designed and set in Bembo, Bembo Expert
and Meta by AW & DL @ Axis Design,
Manchester
Printed and bound in Singapore by
Craft Print International Ltd

Preface

Lewis Biggs, Director
Tate Gallery Liverpool

From its opening in May 1988, Tate Gallery Liverpool has been dedicated to broadening the audience for Modern Art through the innovative use of the National Collection. One of its opening gambits was the Mobile Art Programme, designed to take the activity of the Gallery into the community.

After a year or two, with the Gallery's profile established, attention turned to longer-term dialogue with strategic sections of the community. Young Tate was born from the recognition that young people outside education have a special freshness of vision but are frequently neglected by cultural organisations. The principle of peer-led learning, which underpins all Young Tate activities, maximises rewards for the young participants and also, of course, the potential for institutional learning on the part of the Gallery.

Young Tate was initiated by Toby Jackson (former head of Education at Tate Gallery Liverpool), but its development has been very much the result of the work of Naomi Horlock, who has nourished and facilitated the programme and its activities throughout its existence. This book is as much a monument to her energy and beliefs as to those of the young people who did the work.

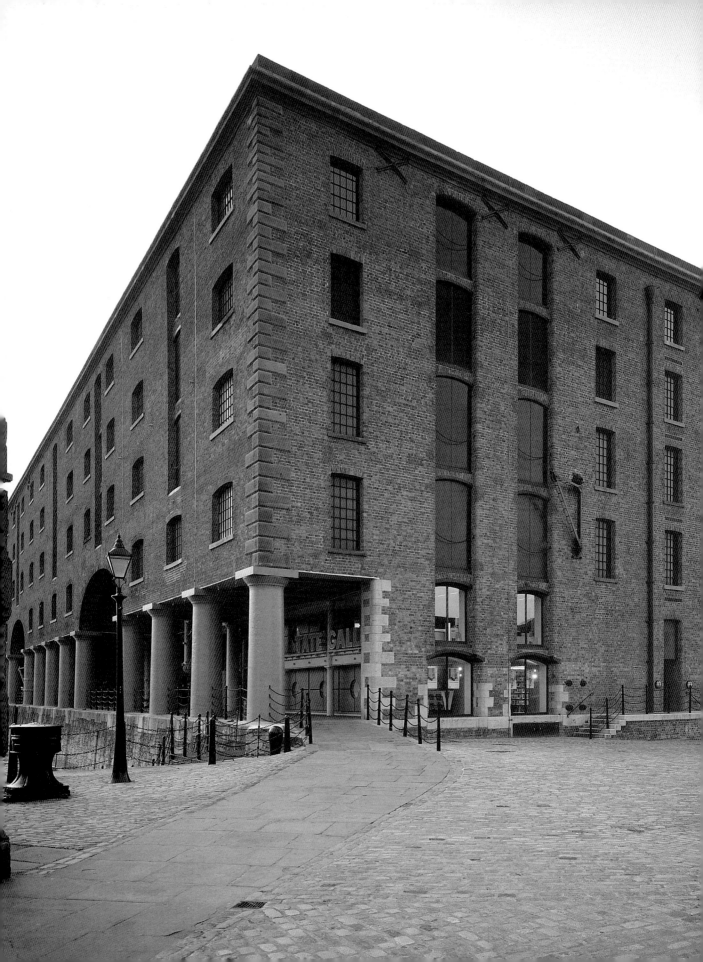

CONTENTS

Acknowledgements

SPONSORS

Tate Gallery Liverpool would like to thank the Calouste Gulbenkian Foundation for making this book possible, and for its continued support and funding of the Gallery's work with young people over the last ten years. We thank the Baring Foundation and the Volkswagen Audi Group for sponsoring the Mobile Art Programme (MAP). We are also grateful to Tate Friends Liverpool, for their support of the Young Tate *Newsletter* and web-site project.

The Gallery also extends warm thanks to the Ian Short Partnership for their sponsorship of the display 'Testing the Water', in many ways a 'watershed' event.

YOUNG TATE MEMBERS

For their contributions to this book, Tate Gallery Liverpool would particularly like to thank Gary Clarke for his hard work on the paper for the North West Arts Board conference, entitled *Taking the Plunge: young people and art galleries* (1995). Thanks to Soraya Lemsatef, Liza Lemsatef, Sarah James, Emilia Eriksson and Anitha Darla for their contributions to the case studies, and to all those involved in focus groups. A special thank you to all those young people who established the Young Tate Advisory Group, those who went on to make the 'Testing the Water' display, and the Young Tate members who helped to plan and run the programme of workshops and events. Thanks to Young Tate members who contributed to the first Young Tate *Newsletter* during the Gallery's closure period, and to the team who gave up so much of their time to work on the Young Tate web-site. We thank Emilia Eriksson, Elly Rees and Liza Lemsatef for their work on the Young Tate workshop leaders' course.

THANK YOU TO THE FOLLOWING ORGANISATIONS FOR THEIR HELP, SUPPORT AND ADVICE IN RECRUITING YOUNG PEOPLE TO THE YOUNG TATE ADVISORY GROUP:

Liverpool City Youth Service; Merseyside Youth Association for their support and guidance in the early days of Young Tate; Derek Boak of Sutton Community High School; Linda Lee, formerly of Liverpool Anti-Racist Community Arts Association; Sylvia Young and Sue Lee of the Sanderling Unit at Rock Ferry High School; Diane McDonald of Rock Ferry High School;

George McKane and the young people of Yellowhouse; Joan Hare, formerly of Knowsley Youth Service.

Our thanks to freelance staff who contributed to the Young Tate programme, particularly Gary Perkins, Alan Dunn, Vinny Lavell, Esther Sayers, Anna Morrison and Gill Nicol, and to freelance staff involved in 'Testing the Water': Kate Beales, Fiona Candlin, Helen Coxhall, Charles Hustwick, Gerri Morris and Angie Whitbread. We are grateful to Paul Willis for his advice and support in the early days of Young Tate.

Special thanks to Fiona Bradley, former Exhibitions Curator at Tate Gallery Liverpool, for her hard work, enthusiasm and patience throughout the 'Testing the Water' experience, and staff at Tate Gallery London, who entered into the spirit of a novel set of demands with great goodwill.

Young Tate and the Gallery extend their thanks to the British Youth Council, particularly Chris Vallance, Training Officer, for advice and support in planning and implementing the Young Tate workshop leaders' training course.

EDITOR'S NOTE

I would like to thank Pam Meecham and Anne MacPhee for their feedback and advice on the text, and to Camilla Jordan-Baker for her help with aspects of the Introduction. Special thanks to Toby Jackson, Jemima Pyne, Robin Bloxsidge and Helen Ruscoe for their help in editing the text, and to Adrian Plant for his help in accounting for the development of outreach work at Tate Gallery Liverpool, and for allowing me to use extracts of his article in the *Journal of Education in Museums* in Story 2. Thanks also to Lindsey Fryer, Catherine Orbach and Elisa Oliver for their patience in reading and commenting on the text.

Finally, thank you to staff at Tate Gallery Liverpool for their continued enthusiasm and support for the Young Tate programme.

Naomi Horlock
Young Tate Co-ordinator

CALOUSTE
GULBENKIAN
FOUNDATION

Foreword

Simon Richey
Assistant Director (Education)
Calouste Gulbenkian Foundation (UK Branch)

Some years ago the Calouste Gulbenkian Foundation's Education Programme commissioned Paul Willis to undertake an enquiry into the cultural activities of young people. The report of the enquiry, a shortened version of which appeared in 1990 under the title *Moving Culture*, argued that young people are continuously engaged in imaginative, expressive and decorative activities – the activities of popular culture, if you like – and that our traditional notion of what constitutes the 'creative' or the 'artistic' ought to more readily embrace this. The report also argued that established cultural institutions such as theatres, galleries and concert halls should develop programmes for young people that were more consonant with their day-to-day cultural activities, even if one of the purposes of such programmes was to serve as a stepping stone to more ambitious developments in the future.

Subsequent to the publication of *Moving Culture,* the Foundation introduced a funding priority designed to promote the report's recommendations, a practice we frequently adopt.

It was at this time that Tate Gallery Liverpool wished to develop an initiative that deliberately forged links between the two worlds of the Gallery and local youth culture. The project was so consistent with the Education Programme's new priority that the Foundation agreed to fund it. It was the first of a number of such grants to the Gallery, a precursor of the grant aid we were able to offer over a number of years to Young Tate.

The need for projects like the Young Tate is as pressing now as when it first began. Many young people continue to leave school with neither the confidence nor the enthusiasm to visit galleries (or theatres, or concert halls), and thus forego a whole area of experience that many of us take for granted, 'Crossing the Line: Extending Young People's Access to Cutural Venues' is the name of a recent Foundation report that explores this issue in depth. It is to be hoped that the pioneering work described in the pages that follow will help others, and so encourage greater numbers of young people to cross the threshold of galleries and begin to feel at home there.

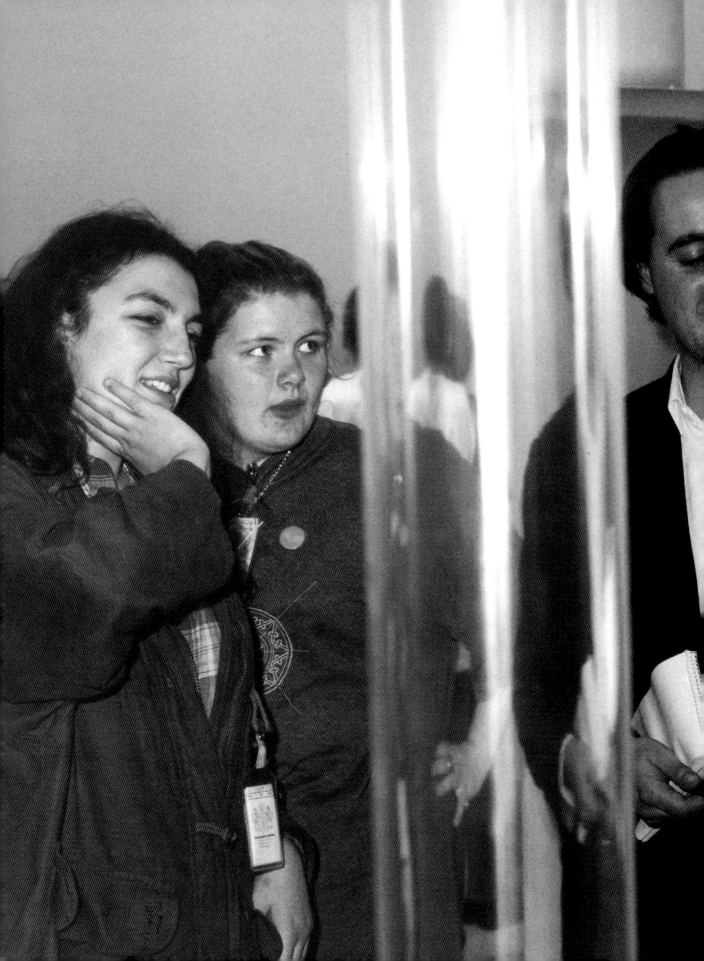

INTRODUCTION
Tate Gallery Liverpool
and Young Tate

Naomi Horlock
Young Tate Co-ordinator

Tate Gallery Liverpool opened to the public in 1988 and is part of the popular Albert Dock, a complex of nineteenth-century Grade II listed warehouses. The Gallery undertook a renovation programme in 1997 which provided new facilities such as the fourth-floor gallery space for contemporary exhibitions, and on the ground floor the café Taste and the Tate Shop which supports the Gallery's work with a range of books, cards and gifts. Interpretation and information material is brought up to date within the gallery by the use of new information systems.

Tate Gallery Liverpool exhibits work from the National Collection of Twentieth-century Art, which comprises some 3,000 paintings and sculptures, and 7,500 works on paper. In addition to these displays the Gallery initiates an international programme of contemporary exhibitions from around the world. These exhibitions provide critical juxtapositions to the displays and provide a place for issues not addressed within the National Collection.

The Gallery aims to make its displays and exhibitions accessible for all audiences, endeavouring to create a climate for enjoyment and one which develops knowledge and understanding of the ideas and issues raised by the work on display. Developing the relationships between artists, their work and our audiences is at the core of our philosophy.

The Gallery attracts over half a million visitors a year from a diverse range of social and educational backgrounds. Education programmes at Tate Gallery Liverpool broadly reflect this audience through programmes which have been developed for young people and adults in

activities for the Family, Schools and Colleges and Community Groups. Public talks and lectures are targeted at various segments including arts professionals and those studying alongside new audiences.

TESTING THE WATER

This publication came about in response to the growing professional interest from the UK and overseas in the relationship between galleries and their young audiences outside formal education. Tate Gallery Liverpool has established an international reputation for its approach to youth audience development through Young Tate, a programme for young people aged between fourteen and twenty-five. We believe that working with young people to develop a sustainable approach to audience development makes our programming more relevant to the needs and interests of young people.

We have entitled this book *Testing the Water* to reflect our commitment to continuing to learn from our young audiences. It also makes reference to the display selected by members of Young Tate which was shown at the Gallery for six months from September 1995-March 1996. 'Trying out' ideas, responding to young people's feedback, and creating a culture of familiarity or 'ownership', has been the key to shaping a policy for Young Tate.

The Young Tate programme began life in 1994 as an Advisory Group of around twenty-five young people. It has since evolved into a series of peer-led workshops, holiday projects, events, curating and interpretation projects, and has been the subject of several case studies[1] and research. Young Tate was supported by the Calouste Gulbenkian Foundation, and this publication has been partly funded by the Foundation with the aim of disseminating the Gallery's work with young people. Published material on the specific subject of the relationship between young people and galleries in the UK remains limited to a handful of reports.[2] Although Young Tate has been the subject of three internal yearly reports, it was felt that the time was right to reflect on Tate Gallery Liverpool's role in setting out to create a workable strategy for sustainable youth programming in galleries.

The Young Tate programme continues to be strengthened using strategies developed with young people for young people.

Testing the Water is divided into seven sections, each containing a Story and a Case Study related to Tate Gallery Liverpool's development of work with youth audiences. Each section is then complemented by an Essay which expands on the themes of the narrative from the perspectives of gallery and museum education, ethnography, social science, and exhibition and gallery management practice.

[1] Case studies include: Sara Selwood and Shona Illingworth, *Museums and Young People* (London: Museums Association) 1997; David Anderson, *A Common Wealth: Museums and Learning in the United Kingdom, A Report to the Department of National Heritage* (London: Department of National Heritage) 1997; J. Seargeant and J. Steele, *Consulting the Public. Guidelines for Good Practice* (London: Policy Studies Institute) 1998.

[2] In discussing the subject of young people and museums and galleries, the following reports are concerned with this audience outside the remit of formal education: Sara Selwood, Sue Clive and Diane Irving, *An Enquiry into Young People and Art Galleries* (London: Art and Society) 1995; Suzanne Rider and Shona Illingworth, *Museums and Young People, on behalf of Artswork* (London: Museums Association) 1997.

Young Tate was initiated by Tate Gallery Liverpool in 1994 in the belief that developing the Gallery's young audience required long-term institutional commitment and funding. The methods through which the consultation process operates are flexible and regularly monitored; the demise of the Advisory Group, for example, has led to a more focused and effective project-led approach to consultation. It has also allowed newer members to become involved in specific projects such as the BBC Radio Merseyside *Young Tate Debate*. Projects like these enable young people to play a more proactive role in working with the Gallery, equipping them with the relevant background knowledge and encouraging them to develop informed critical responses.

Peer-led work remains at the centre of Young Tate's services, its influence shaping and modifying the programme in response to feedback from Young Tate facilitators and participants. Workshops and projects will continue to bring artists and Young Tate leaders together with young people, bridging the gap between young people, the Gallery, and the twentieth-century art on display.

What has emerged over the last five years is that young people are a loyal and highly articulate audience. Consultation over an extended period of time has allowed Tate Gallery Liverpool to fine-tune its services for young people. The Gallery's support and commitment to Young Tate's development has been firmly established. This commitment is tempered by a clear belief in responding to young people's informed advice, and by the value of peer-led work in planning and delivering programmes for Tate Gallery Liverpool's young visitors.

Chapter One

★

STORY

Young People and Art Galleries

CASE STUDY

Ten Things Young People Say about the Experience of Art Galleries,
and Ten Changes Young People Ask of Art Galleries

ESSAY

With Visitors in Mind:
The Museum with Permeable Walls

STORY

Young People
and Art Galleries

Naomi Horlock

The research showed a market which is younger than average for a museum or gallery, though, while not disputing that Tate Gallery Liverpool attracts large numbers of young people, the quantitative research findings are likely to have been biased by the 'Video Positive'[1] audience.[2]

[1] Video Positive – an exhibition of electronic art, part of the biennial Video Positive Festival, which attracts students nationally and internationally.

Tens of thousands of young people visit art galleries and museums every year, usually as part of an organised school or college trip. In 1991 an Arts Council survey revealed 29% of people aged sixteen to twenty-four visited art galleries across the UK,[3] while market research commissioned by Tate Gallery Liverpool revealed that over a two-year period (1990-1992) sixty per cent of all visitors were aged under thirty-five.

Yet it is this particular age range, especially those under the age of twenty-five, that is said to be the most difficult audience to attract outside formal education. For many of us, our first memory of a visit to an art gallery will always be linked to a school trip; it is education, as opposed to enjoyment, that is more readily associated with the gallery experience.

From an early age, art is introduced as a practical activity; we are encouraged as children to produce art, and to become 'good' at it. Because the emphasis is placed on the making of art and the development of technical skill, especially drawing, exposure to the work of artists shown in galleries can become disconnected from our expectation of what art should be. The gallery is seen as the domain of the informed and the knowledgeable, a world away from the concerns of everyday life.

[2] Tate Gallery Liverpool Marketing Audit, Gerri Morris, October 1993.

[3] RSGB Omnibus, Arts & Cultural Activities in Great Britain. Fieldwork 12 June-7 July 1999 for the Arts Council of Great Britain.

It is this idea of knowledge, coupled with a perceived lack of personal skill or talent for art, which contributes to young people's reluctance to re-visit an art gallery in their own time. The relevance of the gallery to an individual's interests and personal experience is also an issue. Unless young people are studying art at school or college, there are rarely curriculum-centred motives for making the effort. Young people are shrewd and selective in organising their leisure time. For a visit to an art gallery to be appealing, especially with a view to a return visit, something beyond the curriculum is required to maintain interest. Harland, Kinder and Hartley's findings support this view:

> *The evidence from research would suggest that many young people recognised their need for additional skill acquisition in the arts through workshops, tuition, etc., and indeed would welcome such support and structure.*[4]

4 J. Harland, K. Kinder and K. Hartley, *Arts in their View: A Study of Youth Participation in the Arts* (Slough: National Foundation for Educational Research) 1995, p. 278.

The appeal of an art gallery to the individual young person is often very specific. Tate Gallery Liverpool's recent exhibition 'Salvador Dalí: a Mythology' attracted young visitors in their own time as well as in school or college time. For many young people, their motivation for visiting had as much to do with study as with enthusiasm for a familiar and popular artist. One A-level student, now a member of Young Tate, travelled on at least three occasions from Birmingham to see the exhibition and attend related events. On the other hand, the exhibition 'Joan Miró: Printmaking from Figuration to Gesture' (1996) held less popular appeal for young people visiting independently, but Young Tate events linked to the show were fully booked.

The appeal of one artist may not be enough to encourage a young person back to the Gallery to develop their knowledge of others. For other young people who are not studying art, or who have left art well behind them on leaving school, the showing of work by an art 'superstar' may still not be a good enough reason to make the trip. Without a connection

to their own concerns, the Gallery represents an unwelcoming and irrelevant institution, devoid of warmth and steeped in elitism. For others, the existence of a regular programme of informal activities – at weekends, during the holidays and after school/college – enables young people to familiarise themselves with the Gallery and the art it shows. 'Unlocking' the Gallery is the key to making its programmes available, and developing links with young people through organised educational, youth and community visits is as important as making programmes for young independent visitors.

It was Paul Willis's influential study, *Moving Culture* (1990), commissioned by the Calouste Gulbenkian Foundation, that highlighted the wealth of creative activity young people involve themselves in. With reference to museums and galleries, he talks about 'de-institutionalising' these institutions, and advocates 'some kind of psychological ownership'. He goes on to suggest that for these 'high art' institutions to attract and be of relevance to young people, they must first be colonised by them.[5]

For young people to return to art galleries in their own time, relevance, enjoyment and learning are essential elements for a successful experience.

5 P. Willis, *Moving Culture: an Enquiry into the Cultural Activities of Young People* (London: Calouste Gulbenkian Foundation) 1990, p. 59.

Ten Things Young People Say about the Experience of Art Galleries, and Ten Changes Young People Ask of Art Galleries

Jane Elliot

'I could walk into the Tate and no problem whatsoever, but I'd feel a bit of an alien walking into any other gallery. Only because I've been to the Tate that many times though. I'm used to it; it's like my gallery home.'

The following direct quotes are taken from research commissioned by Tate Gallery Liverpool undertaken by Jane Elliot in December 1997-January 1998. Three focus groups were convened: the first drawn from core Young Tate members involved with the programme since its inception, the second from young people who had participated in Young Tate activities, and the third from a group of local A-level art students who had never heard of Young Tate or visited the Gallery. As might be expected, the Young Tate members had a lot more to say about their experiences of art galleries than the other young people.

TEN THINGS YOUNG PEOPLE SAY ABOUT THE EXPERIENCE OF ART GALLERIES

Galleries are uninviting...boxed off...segregated

It's easy to walk past

They're not very well publicised

It is actually quite interesting once you get in there

It seems like a library, too quiet

They make you nervous, the other people there...watching your every move

Intimidating

There is a stigma attached to them, which puts people off, kind of highbrow

The 'approachable' gallery staff don't look approachable

Young people especially don't go – it's not trendy

TEN CHANGES YOUNG PEOPLE ASK OF ART GALLERIES

Put posters up around town

If there was a bus running, going to the Tate, back and forth, it would encourage more people

We need more accessible opening hours

A more comfortable sociable place

Brighter colours

Change the layout of the gallery

Music in the background

There should be more activities going on, and people you can talk to

Maybe there should be special days, like event sessions or something like that

Could there be a resource centre or a base for educational purposes... that would have the internet there and lots of books

With Visitors in Mind: The Museum with Permeable Walls

Toby Jackson

When Tate Gallery Liverpool opened in 1988 it was different in style and purpose to its parent organisation, the Tate in London. In this paper I will discuss the relations between the Gallery, its locality and its visitors.

TATE GALLERY LIVERPOOL

Tate Gallery Liverpool is located in the once thriving port city of Liverpool, more recently known as the home of the Beatles and, since the long decline of its dominance as a trading port, as a city of unemployment and poor housing: a neglected cityscape. The city now shows signs of renewal. European and UK Government funds have helped to increase inward investment, and derelict sites re-emerge as new building, tourism, night-clubs and cafe-bars are transforming the urban blight.

The Albert Dock, as it is today, is evidence that this investment has paid off. For many years, the nineteenth-century dock warehouse overlooking the Liverpool waterfront sat derelict, having outlived its use. It has now been transformed into a tourist location with a mix of shops, bars, cafes, apartments and museums – attracting six million visitors each year – and has become a symbol of the city's re-generation. Tate Gallery Liverpool occupies part of the renovated Albert Dock, and it is against this background of urban decline and renewal that the Gallery and its relation to 'community', or a broader notion of its audience, must be seen.

Tate Gallery Liverpool's primary functions were, and still are, to display the Modern Collection (the corporate Tate has two National

Collections – Modern Art, and British Art from the Sixteenth Century to the Present Day), and to engage visitors, many of whom were described in early discussions as 'new to modern art'. Unlike most museums of art, many of the traditional 'museum' functions – acquisition, storage, conservation and cataloguing – are done by the Tate in London. Tate Gallery Liverpool, therefore, can concentrate on making and interpreting displays for its visitors. Works from the Modern Collection are transferred to Liverpool from the store in London, and returned at the end of a display. Tate Gallery Liverpool pioneered the concept of changing the Collection displays, with varying cycles of change.

When the Gallery opened to the public in 1988 the art in the building was arranged like a sandwich, with the Modern Collection displays on the ground and second floors, and a loan exhibition on the first floor. On the ground floor, entrance level, visitors to the newly-opened Gallery would have seen two separate displays, each lasting one year. One was Mark Rothko's gift to the Tate of nine paintings, some of which had originally formed part of a mural project commissioned by Philip Johnson (the architect of the Four Seasons Restaurant within Mies van der Rohe's Seagram Building in New York); the other was a display entitled 'Surrealism in the Tate Gallery Collection'. Surrealist art is one of the Tate's strongest holdings in the Modern Collection, and it owes much to the foresight of Sir Roland Penrose,

who championed Surrealism in England and was the principal organiser of the International Surrealist Exhibition in London in 1936. In addition to being a Tate strength, Surrealism was chosen because of its popular appeal – it is one of the few household names in modern art. The display included objects and artefacts admired and collected by Surrealists, to engage visitors with tangible evidence of the Surrealist project.

On the second floor was a display of modern British sculpture, which would last for three years. Arranged broadly chronologically, starting with the return to carving in the early years of the twentieth century, the display was intended to provide the 'museum' experience – encouraging visitors to return with a friend to see favourite works and to serve as a study collection for schools, colleges and continuing education. This practice has continued with a series of three-year displays, representing work from throughout the twentieth century. The filling in the sandwich was an exhibition of contemporary British art entitled 'Starlit Waters: British Sculpture an International Art 1968-1988' – an exhibition which 'spoke to' the displays, a rationale that we continue to apply to loan exhibition selection.

The Rothko display was followed nine months later by 'Dynamism: the Art of Modern Life Before the Great War' in which Futurist, Rayonist, Vorticist and Simultaneist works were joined by telephones, aircraft propellers and other examples of new technologies admired and quoted by artists in the early years of the

twentieth century. Pink labels referencing *Blast*, the Vorticist manifesto, proclaimed the spirit of the age. Visitors enjoyed the link between familiar objects from outside the art museum and the unfamiliar forms of early twentieth-century art.

The launch campaign in the spring of 1988 employed commercial marketing techniques to promote the Gallery as a place to visit. The optimism for the power of modern art to intrigue and engage is evident in the promotional television and poster campaigns. 'Be There or Be Square!' they proclaimed. Here, modern art speaks directly to you in a language that is ostensibly modern, yet wittily engaging.

Tate Gallery Liverpool employed a team of Information Assistants, whose dual role was to engage directly with visitors in the Gallery – informing them through informal conversations about the art on display, and to look after the artworks. Tate Gallery Liverpool was perhaps the first major museum in the UK to adopt this practice. The Information Assistants included young and old, male and female, ex-dock workers and recent graduates, all of whom were full-time members of staff. Visitors welcomed the opportunity to ask questions on the spot in an informal way, and told us how these encounters helped to dispel their lack of confidence in visiting the art museum. Others told of the 'un-museum' feel of the building, its warehouse features having been left in place by the architect of the conversion, James Stirling.

The Gallery has made many interventions in the museum space in recognition of visitor needs. An early example happened during the 1988 Surrealism display. In 1936 Roland Penrose invited the public to exhibit their own 'surreal' objects; Tate Gallery Liverpool repeated this invitation, advertising in the local press and in the Gallery. Every surreal object was accepted – from young children's to international artists' submissions – and the results were displayed in the galleries and celebrated at a private view attended by participants, their friends and families.

The Gallery also attempted to show that modern art has many readings; using the 'Modern British Sculpture' display, young people were encouraged to research issues around 'primitivism' and the representation of women in twentieth-century art, and presented their findings in extended labels placed adjacent to selected sculptures. This inclusion of voices other than the authoritative voice of the museum was one of a series of projects in which we opened up the Gallery and its collections to critical debate.

EDUCATION

What, then, is the role of the Education team? In addition to working on the projects already mentioned, we set out to find ways of working outside the Gallery making contact with communities that were unlikely to visit. The aim was to establish a network of potential partners, and to devise a methodology that was

interactive and focused on discussion-based activity, rather than relying on making activities for young people and didactic methods for adults. This entailed developing group-work skills amongst the team of Gallery workshop leaders, and making resources that could be used in the galleries. In addition, the Gallery adopted a marketing approach to visitors, targeting specific groups with rolling programmes of events, each programme with its dedicated Education Curator, marketing strategy, learning methods and resources. The Gallery's predominantly heuristic approach to learning defines both the tools we use and the practices we employ. For example at Art Quest, a weekend programme for children with accompanying adults, visitors choose from four trails and participate in a sequence of activities directly in front of artworks. All activities help visitors to construct a range of responses through participation and discovery.

As part of a move to integrate Tate Gallery Liverpool into the locality, the Education Department set up an outreach programme run by a full-time co-ordinator. The aims were to show that the Gallery wanted to work with community organisations, and would welcome and provide services to all sectors of the community (to counter the view that the Gallery was only interested in the art world audience), and to demonstrate that the Modern Collection was a unique resource that could contribute to the ambitions of a wide range of community programmes.

The initial brief was to first research arts activities in the locality, looking for programmes, activists or projects that we might relate to, then to investigate potential collaborations, and finally to set up six long-term programmes that would operate both outside and inside the Gallery, and link the Modern Collection to the agendas of the participating organisations.

One of the organising principles was to introduce the Gallery's policy of attempting to engage non-visitors with the Collection to the agendas of the partner community organisations. This takes sensitivity and patience, and much of the early work focused on developing this strategy. We had broad categories of non-visitors in mind – young people outside formal education, adults who were unlikely to visit the Gallery, and mental health groups. We established the principle of working quietly over several years, ending a programme only when a legacy of self-support had been established (by that I mean confident use of the Gallery programmes and resources). After ten years the Gallery retains a presence, usually in the form of membership of steering groups.

At the outset we rejected involvement with large-scale, high profile, short-term projects, unless they contributed to or grew out of the long-term aims of the outreach programme. For example, the legacy of six years' outreach work with a local town enabled the Gallery to successfully make a new work by Antony Gormley. *Field for the British Isles* (1993) was an

ambitious project, a sculpture which comprised more than 40,000 handmade figures. Because of the success of our long-term outreach work with communities in St Helens – a small town outside Liverpool and the site of a brick factory – we invited Sutton Community High School's staff, pupils and their families to help make *Field*. The resulting work was the centrepiece of a major retrospective of Antony Gormley's work which not only attracted international attention, but also drew large numbers of local people, many of whom had never visited the Gallery before, to see the results of their work.

In 1989, Tate Gallery Liverpool set up the Mobile Art Programme – an outreach initiative under the acronym MAP – which for four years concentrated on working with young people outside formal school education between the ages of fourteen and twenty-five.

MAP visited many youth organisations within a two-hour radius of the Albert Dock, and brought young people back to the Gallery for debate and argument about the Collection. It has worked closely with youth arts workers and regional and national youth organisations to devise appropriate programmes, and to ensure that we were working within the legal framework of pastoral care for young people. Some aspects of this programme focused on learning about modern art, others concentrated on learning from art. We used the Collection to open up debate about issues that were of significance to young visitors. For example, we worked with Artworks, a drug rehabilitation

organisation. Some critics claim this is, in essence, social work and outside the remit of the museum. I would claim that the museum benefits from opening up its collections in this way.

RECEPTION

As I commented earlier, the new Gallery was set up to show the Modern Collection more widely, and this underpinned our motivation to consider the implications of engaging with non-art-world visitors. At this time the notion of the museum was changing from a dominant pre-occupation with the art object and associated scholarship, to a culture that accommodated the needs of visitors. Ideas about customer care (and associated management strategies and qualitative visitor audits) were penetrating the walls of the museum. Two other motivating factors were apparent: first, that we were opening in a city with a long history of prosperity followed by decline, now an urban re-development region, recognised as one of the poorest regions of Europe; and second, the reception we received in 1988 was mixed, and contained much adverse criticism – particularly from the city and local communities.

It would have been easy for Tate Gallery Liverpool to sit back and be satisfied with its performance: in 1988 the projected figure of 200,000 visitors a year was actually 700,000, and has hovered around 600,000 since then. Yet it is indicative of the challenges faced by the Tate in setting up a new gallery in the north of

England that it listened to the voices of dissent. I would like to take time at this point to describe some of these voices.

One of the most controversial and frequently quoted works of modern art in the UK is Carl Andre's *Equivalent VIII* (1966), purchased by the Tate in 1972. The popular press were outraged at this waste of public money. The sculpture has now entered popular mythology as the 'Bricks' and is a conduit for all that is felt to be absurd about modern art. Not wanting to miss an opportunity to chastise modern art again, the popular press announced in banner headlines: 'We've had the Bricks now we've got the Bread'. They continued to be disgusted by Antony Gormley's use of sliced bread in his work *Bed* (1980-81) – wasted on art, whilst 'millions starve in the world' – deaf to the meaning of the work that drew attention to our relationship to food, from an artist who trained as an anthropologist.

Others within the community asked fundamental questions about the nature and place of an art museum set in a city which is itself struggling for an identity in the globalisation of our lives, against the harsh social and economic realities of the late twentieth century.

During discussions in Liverpool about urban renewal and the need for the city to seek a new identity, the Albert Dock and Tate Gallery Liverpool were promoted as symbols of regeneration. Urban development specialists pointed to the importance of establishing a sound infrastructure, and providing high quality cultural and leisure activities in order to attract major investors and manufacturing industries to the city. This fitted with Tate Gallery Liverpool's mission statement: to integrate itself into its local and regional homes. Yet this is a very limited view of the Gallery's civic role, and the ambition of the Gallery was to integrate itself into its locality in other ways.

For some members of the black communities the Albert Dock development was seen as a cynical compensation for the street riots in the city in 1982, although Merseyside Development Corporation insists that its plans were already in place prior to this date. Liverpool, as a consequence of the slave trade and its earlier prominence as a trading post, has the second oldest black community in Britain.

To what extent Liverpool's past wealth is dependent on the slave trade is currently under debate, but it is an issue that has not yet been reconciled. For some the site of the Gallery on a Liverpool dock (a place associated with slavery and exploitation), and the Tate Gallery's own history (Sir Henry Tate, of Tate & Lyle sugar, was the original benefactor of the Tate Gallery in London), are reasons to link Tate Gallery Liverpool to the black community's struggle for identity, recognition and retribution.

Some observers of relations between the Tate Gallery and market forces criticised the choice of the Albert Dock because of its transformation into a heritage site of museums, shops, cafes and pubs, and the consequent

sanitisation of history for purposes of leisure and entertainment. The Albert Dock context would colour the display and interpretation of art, already under threat from accelerating commodification. 'If the Tate Gallery Liverpool can be described as a signal box', says Jonathan Harris, 'then it is so as part of an international network of institutions and relationships that constitute the *global, modernist art-business circuit.*' Art would also suffer from the legacy of tourism, encouraging casual visitors' ambulation through the Gallery: a confrontation between the high-mindedness of art and the trivia of fast-food outlets and fashion shops.

Ten years on, Tate Gallery Liverpool is now seen increasingly as a city asset, and is now part of the story told to all those with an interest in moving to the city to set up home or business. The reasons for this change are too complex to address here, but it is indicative of late-1990s English politics that those who control local government are now more pragmatic in their dealings with national government and with regional agencies. Of equal significance is the impact of the Gallery's approach to those who visit and to potential visitors. We recognise, then, that the Gallery has a civic role – it adds to the cultural, social and educational life of the city, and in doing so attempts to relate to dominant and less dominant cultural views and interests. Behind this lies the belief that modern art and the museums that display it have the potential to engage with all sectors of society, provided that the conditions are right.

MEANWHILE BACK IN THE MUSEUM

One way of conceptualising the museum might be to think of it in terms of complexity. Greg Lynn, says that 'one approach to a theory of complexity might be to develop a notion of the composite or assemblage which is understood as neither multiple or single, neither contradictory or united'.

The art museum can accommodate difference, organise and programme for different visitors in different contexts without fracturing and without contradictions to a sense of itself. In discussions about the new museum of modern art, what is the curatorial position? For whose benefit are the collections acquired, cared for and displayed? Should the museum play to its strengths and concentrate resources on the specialist visitors, or should it respond to the needs of wider visitor profiles? But are these positions mutually exclusive? I would contend that the Gallery should provide for both, that is, a chance for specialists to enter spaces that satisfy them, and for those who demand more interpretive material and information to find spaces that suit their needs. It also has to include plural readings, particularly those critical of the objects and practices of the museum.

MUSEUM WITH PERMEABLE WALLS

As I have said, the launch campaign and the early programmes are indicative of an 'opening up' of the museum – not exactly a museum without walls, but there is evidence that the walls are becoming permeable. I have called

these activities interventions in the modernist space of the art museum. The Model Bites Back, described below, was one such intervention.

'Venus Re-Defined: Sculpture by Matisse, Rodin and Contemporaries' was a display of early twentieth-century sculpture, which argued that artists based in Paris in the early years of the twentieth century employed technical innovation to progress the modernist project. It included works by Rodin, Matisse, Renoir and Maillol. The Gallery judged that the display would be popular, given that the works were figurative, and would help visitors understand an aspect of the transition from figuration to abstraction. This simple story was considered to be appropriate to incidental visitors, who would come in to the ground floor of the Gallery from a day out on the Albert Dock. We decided to complicate the story, and to use live performance as the vehicle. The Gallery commissioned a theatre group to research and devise a performance that would explore the notion that the nude was the site of the modernist project, and that feminist texts would reveal this story. The performance, entitled The Model Bites Back, burst onto unsuspecting visitors in the foyer, with an apparent visitor shouting abuse at an Epstein nude. Their attention gained, the visitor/actor revealed his purpose to the crowds, and invited them into the display for the rest of the story. The stage was the gallery space, the set the artworks, and the actors spoke of the transactions between

artists and models and revealed the 'hidden' feminist narratives in the work.

The Education team also works with other Gallery departments to make publications and interpretive material: leaflets, extended labels, books and information rooms. One example of this is a pack designed to be used alongside 'Venus Re-Defined'. The content grew out of our workshop methods, and uses contextual images and texts to interrogate the works in the Collection display. Dealing with issues of gender and sexuality proved difficult for some educational users, and many would have preferred a formalist approach in the pack.

A key component in the museum's ability to work with a broad range of visitors is the curatorial organisation. At Tate Gallery Liverpool the Education Department is represented on the Programme Planning Group – a group which develops concepts, then researches and makes displays from the Modern Collection. Also the Head of Education is one of three senior staff in the Gallery. In addition, the Gallery operates a 'pairing' system in which an Education Curator works with an Exhibitions Curator to research and implement a display or exhibition. Without this kind of input at the planning, research and delivery stages, education staff will continue to be reactive to ideas generated by others and a poor cousin to the higher status of those who curate the museum's collections.

schedules to organise a large number of short programmes, linked to return trips to the Gallery.

METHODOLOGY

It is important here to outline briefly the educational philosophy that underpinned the development of MAP and of new outreach methods. This methodology drew on workshop models used in the Gallery to engage people with the ideas and issues raised by the twentieth-century art on display.

The Gallery workshop, facilitated by a freelance artist or a member of the Education team, takes as its starting point the art on display. The aim of the workshop is to develop participants' critical knowledge and understanding of the work, largely through group discussion. Working in small teams, participants are set tasks that encourage them to respond to the work, to question it, and make connections with their own experiences. These tasks are information gathering exercises, and may relate to one or more of the themes that run through a display. Each team chooses, or is given, a work to investigate for a limited time period. They are then asked to report their ideas back to the rest of the group, in front of their artwork. Interpretation of the work is opened up, with participants speaking about the work themselves, as well as listening to each other.

In order to apply this approach to MAP, the team worked with slides and reproductions of the work of artists on show, spending a full day with a group. Images and quotations, and (for a trial period) objects and ideas from 'artboxes' – resources made by artists in response to the ideas of a specific display – were used to help contextualise and provoke discussion about the work in a display. Practical making activities also helped to extend participants' responses to the work.

CONCLUSION

This intensive research and development period with non-formal education, and with some schools, provided the Gallery with the basis for developing its future, more specialist work with young people. In 1992, the Gallery's commitment to long-term youth audience development was confirmed when the MAP Co-ordinator's role became a permanent post within the Education Department. The development of the Gallery's knowledge of youth service provision on Merseyside, through links and partnerships with local youth organisations, became MAP's target. This period gave staff and freelance artists experience of working in a variety of settings with very diverse groups of young people. It also allowed for a working knowledge of youth work philosophy and practice (in statutory and voluntary settings) to be experienced.

Links and collaborations with youth organisations in Merseyside were later vital in helping to access young people for the Young Tate Advisory Group.

Although regarded as a success, by 1993 evaluation of MAP began to indicate that an 'out there' policy aimed at young people outside formal education was limited. One-off workshops were popular and well regarded, but limited in their ability to affect young people's engagement with artworks inside the building. This was in part to do with the geographical distances involved in visiting the Gallery, but another issue also affected the young people's ability to access the building in their own time. Unless they were part of an organised workshop group, there was little to mediate the experience of visiting the Gallery for individual young people. In the summer of 1993, in collaboration with Liverpool City Youth Service and Merseyside Youth Association, the Gallery organised a Youth Arts Weekend with the aim of inviting young people to experience the Gallery through workshops, performances and a debate. This event became the catalyst from which ideas for programming for young people evolved, and led directly to the setting up of Young Tate the following year.

Extracts of Adrian Plant's article 'Expression and Engagement' *for* Journal of Education in Museums (No. 13, 1992) *have been edited and included in this section.*

Youth Arts Weekend
September 1993

Naomi Horlock

Youth workers from Merseyside and the region were invited to bring up to five young people to the Gallery for a weekend of events and debate. On Saturday morning, the young people and youth workers joined one of six workshop groups which took place in every gallery space, including 'Joseph Beuys: The Revolution is Us', and the exhibition 'Elective Affinities'. These workshops were led by visual artists, drama and dance workers, and were designed as a 'taster', or introduction to the range of artists' work in the Gallery.

The remainder of the day was given over to two performances by young people, and a video presentation of the Joseph Beuys-inspired Brilliant Trees project. The first performance was a dance improvisation by Paula Hampson, a former member of Knowsley Youth Dance. The piece responded to the work of contemporary artists in the exhibition 'Elective Affinities', relating closely to its theme of the body.

Bootle's innovative youth arts organisation, Yellowhouse, was commissioned by the Gallery to devise and perform a drama piece in response to a display of their choice. The young people selected the Joseph Beuys display because his slogan 'everyone is an artist' reflected their own philosophy. They had spent a week at the Gallery researching and devising their piece which combined personal statements about their own reactions to Beuys with readings from his writings, set against images from the natural and man-made world. The basalt stones from Beuys' *The End of the Twentieth Century* (1983-85) came to symbolise the creativity of every

individual. A series of challenging questions, painted onto seven-foot banners and hung in the Gallery's studio space, were dramatically unfurled at the end of the piece, and remained hanging for the rest of the weekend.

Brilliant Trees – a collaborative environmental project between the Sanderling Unit (for young people with moderate learning difficulties) at Rock Ferry High School, Birkenhead Park Rangers, St Anne's Arts Centre and the Gallery – focused on Beuys' *7,000 Oaks*, the tree planting work he initiated in the German town of Kassel in 1981-82.

The highlight of the weekend, and the most informative part from the Gallery's point of view, was a panel debate on the Sunday entitled 'What's in it for us? What's in art galleries and museums for young people?' The debate, set up in a *Question Time* format, with a chair and five panellists, was preceded by workshops that set out to prepare questions. By the end of these pre-debate workshop sessions, each group had accumulated a range of topics and had nominated a member of the group to put their question to the panel. Questions raised concerned the selection of works for exhibition, internal and external layout of the building, staff attitudes to young people (particularly front of house), publicity and advertising, and anxiety about a perceived lack of knowledge about the work on display.

The panel, chaired by John Hewitt of Manchester Metropolitan University, included Lewis Biggs, Curator, Tate Gallery Liverpool; Jenny Hand, adviser to the National Youth Agency; Mark Radcliffe, BBC Radio One DJ and presenter of its arts programme *The Guest List*; Shirley MacWilliam, the Gallery's Momart Fellow; and Paul Ainsworth, project worker with Ariel Trust.

Although the debate's theme was centred on galleries and museums in general, young people focused their criticisms and their ideas on Tate Gallery Liverpool. The subjects covered appeared to be strongly influenced by the participants' recent and consequently informed experience of Tate Gallery Liverpool. As the debate progressed, it became apparent that they had a strong urge to know more about the Gallery. The politics which inform the selection of works of art were returned to several times, for example: 'Who chooses and why? How does a work get into the Collection?' The politics of the building itself and the 'messages' it puts across to young people were also issues for the audience. These 'messages' include the intimidatory nature of big institutions which appear to discourage the presence of young people or the 'ordinary' or less 'art literate' visitor, to the prohibitive cost of food in the Gallery coffee shop. Young people felt unwelcome. They stated that front of house staff were in general unapproachable, distant, and too officious. They questioned the age limit for unaccompanied young people, and talked about what they perceived to be visual discrimination. Young people in the audience on the whole felt that security staff in galleries assumed that as they were

young, trouble would naturally follow. It was conceded by some, however, that the high spirits of some young visitors might play a part in this assumption.

As well as questions, the suggestion was put forward by the audience for a kind of 'young Tate', made up of young people who could advise the Gallery about ways to make the building, and the art shown in it, less intimidating and more appealing to young visitors. This idea, along with feedback which indicated young people were interested in regular programme as opposed to one-off events, led directly to the Gallery's decision to set up the Young Tate Advisory Group.

ESSAY

Beyond *L'Amour de l'Art*: Youth, Cultural Democracy and Europe

Ullrich Kockel

In a debate on culture and European integration, the Polish theatre director, Izabella Cywińska, argued that culture, rather than being an integrative factor, is what *divides* people, whereas civilisation *unites* them.[1] This polarity between culture and civilisation underlies much of especially Central European cultural theory. The best known early postulate of the polarity can be found in Tönnies' work *Community and Society*, where community is portrayed as a 'living organism', as opposed to the 'mechanic aggregate' which is society.

The distinction has been perpetuated by twentieth-century cultural sociology. Alfred Weber saw culture as the spiritual, emotional and idealistic side of human life, while civilisation was regarded as technological, subsistential and materialistic-utilitarian. In a

sense, then, culture became the spiritual 'realm of freedom', while civilisation signified the material 'realm of necessity'.[2] For Marcuse, culture − as high culture − is those 'authentic' works of literature, music, art and philosophy which society, through the process of civilisation, has adopted, organised, bought and sold, thus making them increasingly accessible to an ever-growing number of people. As a result, the autonomous, critical cultural values have been transformed pedagogically, recreationally, into a means of relaxation that becomes a vehicle of societal accommodation:

> [D]ie autonomen, kritischen Kulturgehalte [werden] pädagogisch, erbaulich, zu etwas Entspannendem, ein Vehikel der Anpassung.[3]

[1] I. Cywińska, 'Es gilt, die Maske herabzureißen oder: Die Rolle der Kunst bei der Umgestaltung Europas', in *Der Umbau Europas. Deutsche und europäische Integration. Die Frankfurter Römerberg-Gespräche*, ed. H. Hoffmann and D. Kramer (Frankfurt/Main: Fischer) 1991, pp. 99-102, at p. 100.

[2] H. Marcuse, *Kultur und Gesellschaft*, 2 vols (Frankfurt/Main: Suhrkamp) 1968.

[3] Ibid., vol. 2, p. 155.

17 U. Eco,
*Apokalyptiker und
Integrierte. Zur
kritischen Kritik der
Massenkultur*
(Frankfurt/Main) 1984,
p. 51; quoted in
Kramer,
'Marktstruktur',
pp. 44-45.

As an alternative approach, Umberto Eco[17] and others postulated a more dialectical relationship between 'producers' and 'users' of culture. Interestingly, this idea has been picked up with considerable enthusiasm by positivistic sociologists and policy makers, with their unswerving belief in the regulatory powers of the market exercised by a rather imaginary 'autonomous consumer'.

In *L'Amour de l'Art*, Bourdieu posed the important questions of who consumes 'culture', and what sort of 'culture' is consumed by different groups. Moreover, he considered the social effects that this consumption has. Again, as with Eco's proposals, this focus on consumption has meant that his intentionally critical analysis was eminently suitable for absorption, with minor adjustments, into the Marketeering ideology that has swept the Western world in the last two decades. While pretending to ameliorate the problems identified by the critics, the Marketeers have succeeded, perhaps unwittingly taking their cue from Eliade's 'demystification in reverse',[18] in shifting the action to a different playing pitch. Having declared Bourdieu's historically conditioned consumer to be an autonomous economic actor, they can now lay the blame for any persisting barriers squarely at the feet of the underprivileged and represent the bourgeoisie as completely vindicated. Consequently, the indictment can be thrown out on the basis of Bourdieu's own argument. Or can it?

18 M. Eliade, *The
Quest: History and
Meaning in Religion*
(Chicago and London:
University of Chicago
Press) 1975.

GRASS-ROOTS REACTIONS: THE ALTERNATIVE MOVEMENT

Bourdieu's *L'Amour de l'Art* was written in the late 1960s, at a time when, initially influenced and, to an extent, driven by the student movement, a new counterculture developed especially in Germany which absorbed and transposed much of the cultural criticism coming mostly from the academic 'high ground'. This counterculture, which came to be known as the alternative movement (*Alternativbewegung*), encompassed a range of smaller sub-cultures and shared common themes with a number of parallel social movements, such as the Greens, and the peace and the anti-nuclear movements. In fact, it had so much in common with the Greens that in public perception the two movements often merged into one, and the differences only became apparent during the escalation of a conflict between the 'fundis' (the mostly extra-parliamentary fundamentalists) and the 'realos' (the parliamentary opposition) within the Greens. The alternative movement – like its ideological precursors, the life reform and the youth movement, earlier in this century – had a profound impact in many spheres of everyday life and popular culture over a period of fifteen to twenty years. Their impact on German society is still widely apparent, although a new generation of youth with a vastly different set of cultural values has superseded the alternative movement since the 1980s.

The ideology of the alternative movement

revolved around lifestyles, including in particular ideas about education, aesthetics and what might be termed an 'art-ification' of everyday life. The well-known postulate that 'everyone is an artist' (Beuys) is a perfect expression of the *Zeitgeist* which produced this movement. 'Street Art' and the 'Happening', forms that were originally developed in different contexts, became part of the alternative lifestyles propagated by the movement. Museums and galleries, rather than lecture halls, were chosen for meetings of a distinctly political nature that had little to do with the exhibits. At the same time the institutional boundaries between exhibitions and everyday life became increasingly fluid as works of art were being displayed in the most unlikely places. Eco's dialectical relationship between 'producers' and 'users' was enacted more or less provocatively in virtually all spheres of everyday life, and the generation of the alternative movement no longer viewed the theatre, museum or gallery as a sacred space reserved for the display and consumption of high culture. On its extremist fringes, the movement turned even more iconoclastic with the demand to close the institutions of 'high' culture and return their contents to the 'real' people.

In relation to art, as in most other areas, the alternative movement was a radical rebellion against hegemonical structures that, unlike the student movement, had no clear-cut class basis and no coherent intellectual leadership. Its cross-class nature and the wide appeal of its radical, but rather undifferentiated ideology gave it a broad social foundation that ensured its lasting impact at least for the life span of its generation (i.e., perhaps another thirty years from now). However, the lack of intellectual leadership – other than in the form of outstanding individuals like Joseph Beuys[19] – prevented it from achieving its more radical goals. Some of the ideas advanced by the movement have been absorbed by the hegemony into so-called community educational programmes. By this process of 'accommodation', the highly confrontational atmosphere of the 1960s and 1970s has been successfully diffused. What remains, to be cynical about it for just a moment, is a fairly substantial proportion among a generation of young parents who – culturally and politically aware, but disenchanted with a market economy where actual consumers are anything but sovereign, and which is being upheld by a political hegemony whose concept of democracy appears to be built on an illusion of citizenship – rest their hopes on the eventual success of their 'long march through the institutions'[20] with their children. Does this mean that the 'apocalyptic' critics were right, Eco and others – with their emancipatory agenda – wrong?

PICKING UP THE PIECES: THE PERIPHERY – EAST AND WEST

The cultivation of 'citizenship' is a major theme in European programmes introduced in the late 1980s and early 1990s, originally to prepare the

[19] See U. Kockel, 'The Celtic Quest: Beuys as Hero and Hedge School Master', in *Joseph Beuys: Divergent Critiques*, ed. D. Thistlewood (Liverpool: Liverpool University Press) 1995, pp. 129-47.

[20] The term was initially associated with the German student leader, Rudi Dutschke who adopted it from Maoist propaganda and transformed it into a political programme for the extra-parliamentary opposition. See R. Dutschke, *Mein langer Marsch. Reden, Schrifen und Tagebücher aus zwanzig Jahren*, ed G. Dutschke-Klotz, H. Gollwitzer and J. Miermeister (Reinbek b. Hamburg: Rowohlt) 1980.

ground for the 'unity in diversity' of a European Union, but since 1989 also to assist the democratic transformation in Central and Eastern Europe. These programmes place considerable emphasis on culture, that is, 'high' culture in the above sense, as a vehicle for this transformation.

A term that has gradually found its way into the vocabulary of administrators in the first instance, and then academics and, more recently, politicians, is 'cultural resource management'. From prehistoric stone circles to computers, from malt whisky to post-modern art – everything is, or can be, a 'cultural resource'. In that sense, 'anything goes'. Given the indeterminate nature of the subject, it is hardly surprising that a host of modern-day mercenaries have descended upon the European periphery, East and West. A new sub-sector of the 'culture industry' has emerged, which operates at the meta-level of consultancy and appraisal rather than everyday practice. This sub-sector tends to be dominated by representatives of what economists and geographers would call the 'core', and who are offering their services to the 'periphery'. The paternalistic approach – against which the rebellion of the alternative movement (and others) was directed – is back in full swing.

Opposition against this 'new colonialism' is voiced by those on the ground, especially in countries with a venerable cultural history of their own, such as the Czech Republic or Hungary. In a scathing indictment of what he regards as essentially American cultural imperialism, the Hungarian sociologist Szász pleads for the recognition of the vital 'interdependence and mutual influence among ethnic, national and world culture in…past and…future'.[21] Taking the subversive folklore movement among Hungarian youth under communism as his starting point, he argues that grass-roots cultural movements could provide the catalyst for a broadly based European cultural resistance to an American hegemony commonly disguised by the pseudo-neutral label of 'globalisation'. His vision of a latter-day *Kulturkampf* is shared by many intellectuals and artists in Central and Eastern Europe. It also resonates with the essentially conservative, culturally 'anti-Western' ideology found in the alternative movement especially on the Western European periphery. But any such opposition must remain confined to rhetoric, for a reason as simple as it is cruel: the periphery, East and West, is financially under-resourced, dependent on a steady flow of funds from the core, which has made acceptance of the culture industry's paternalism a non-negotiable condition for this continued support. Bassand makes the point with some force:

> [P]eripheral regions … are still a weak point in cultural democracy. Why? Because they are threatened in their socio-economic, cultural and political substance; because they are obliged to confine their cultural policy to the defence of their heritage at the

21 J. Szász, 'The role of folklore in the identity of minorities – Mother country and region – Cultural interaction and co-operation', paper delivered at a conference on 'Cultures in Europe: The Cultural Identity of Central Europe', Zagreb, 22-24 November 1996.

22 M. Bassand, *Culture and Regions of Europe* (Strasbourg: Council of Europe Press) 1993, p. 209.

expense of creativeness. In short, regional underdevelopment condemns them to cultural marginality.[22]

Despite structural similarities shared by the periphery, there are also significant differences. In the former socialist countries, an 'extended conception of culture' (*erweiterter Kulturbegriff*) was part of the official ideology.[23] While the propaganda claimed that this conception included all the valuable spiritual faculties and characteristics of the people (*alle wertvollen geistigen Fähigkeiten und Eigenschaften der Menschen*), it also betrayed an underlying vision that was not all that different from the 'high' culture in capitalistic societies with its emphasis on imagination, the capacity for idle enjoyment, and appreciation of beauty (*die Phantasie, die Genußfähigkeit und das Schönheitsempfinden*). This view of culture as a means of existential beautification (*Verschönerung des Daseins*) separated culture not only from the sphere of production, but from virtually all aspects of everyday necessity, thus alienating the majority of people – the working classes – from cultural values.[24] Ironically, then, any attempts to 'educate the masses' and 'bring' culture to them could only increase this alienation further. This was one of the key contradictions of the socialist system that led to its destruction by an unprecedented groundswell of civil courage. In the process, the 'false aesthetics' of the old hegemony were thrown overboard, and new curiosity is now bringing ever-increasing

23 K. Hager, 'Zu Fragen der Kulturpolitik der SED', speech delivered at the 6th Meeting of the Central Committee of the SED, Berlin, 6/7 July 1972; quoted in Greverus, *Kultur und Alltagswelt*, pp. 56-57.

24 See Greverus, *Kultur und Alltagswelt*, p. 57.

numbers of people into theatres, museums and galleries. As one remarkable consequence of this development, the management of 'cultural resources' – meaning primarily these institutions and their contents – has become a key concern on the Eastern periphery. It is frequently represented as being on a par with, if not indeed more important than, industrial restructuring, and seen as a major vehicle for the consolidation of democratic values, as integral components of people's everyday beliefs and practices.

On the Western periphery, people have become disenfranchised by a more subtle ideological process involving an outdated economic paradigm and a rather hostile media industry. The growing gulf between economic core and periphery has added an extra dimension to the alienation of ordinary people from the 'high' culture, a dimension which does not exist in the same way on the Eastern periphery: geographical polarisation. Here, as there, the hegemony is located in social space above – and out of reach of – the sphere of everyday life for the vast majority of people. But on the Western periphery it is also geographically remote, and the socio-economic divide between different parts of a country is largely replicated in a cultural divide. Aspects of this divide, such as religion and language, may pre-date the process of socio-economic peripheralisation and the disenfranchisement of the younger generations in particular, but many aspects of popular culture only arose, in the specific form they have taken, as a response to this process.

In the sphere of art, one grass-roots response to this problem can be seen in the West of Ireland and, to a lesser extent, also in parts of Scotland and Wales – the growth and spread of small private galleries, similar to those introduced by the alternative movement in Germany during the 1970s. If all the major collections are concentrated in Dublin, does this mean that art only belongs to Dublin society? Certainly not, but smaller communities rarely have the resources required to maintain collections. In this situation, mainly younger people – locals as well as immigrants – have taken the initiative.[25] One important implication of the gallery-cafe and similar institutions is that the decision on what does or does not constitute art worth collecting is to some extent taken from those who are traditionally in charge of it. Art has been (re-)introduced to the sphere of everyday life for a large and growing number of people. This introduction has been largely free from any hegemonical interests, and has mapped out a territory for popular culture which has been effectively declared 'off limits' for the 'culture industry'. As a consequence, popular perceptions of what art is, and is about, are changing.

YOUTH, CULTURAL DEMOCRACY AND EUROPE

Sara Selwood[26] has pointed out that political '[c]oncerns about young people generally reflect the state's anxieties for future generations … the creation of *good citizens*, and the need to foster

the country's future workforce'. In the same paper, she asks: 'Can institutions like galleries … deliver the goods promised by cultural policies?' Her rather disheartening conclusion is that galleries lack the resources to provide 'a solid and sustained service for young people', and that, at any rate, they need to invest a substantially larger share of the resources they do have to 'develop significant work with young people' at all. From a policy point of view, the objective here seems to be the creation of 'good citizens' who will be the 'future workforce' – the consolidation of the hegemony, as Marcuse saw it. However, at the current level of resourcing, this is considered impossible to achieve.

European programmes such as GOYA or ICON have sought to address the problem of cultural democracy at a somewhat different level, motivated primarily by the idea of fostering a European cultural identity as the foundation for a European citizenship. This approach has been particularly attractive for Central and Eastern European societies who see both the need, and the potential, for a shared European cultural identity – as an antidote to both Russian and American hegemony – far more clearly than their Western European counterparts. Culture, in this context, has retained some of its emancipatory character. In the West, strategies of 'bringing culture to the masses' have been replaced by attempts to improve the social distribution of 'cultural capital', thus enabling a larger proportion of the citizens and workforce

25 For a general assessment of this movement, see U. Kockel, 'Countercultural Migrants in the West of Ireland', in *Contemporary Irish Migration*, ed. R. King (Dublin: Geographical Society of Ireland) 1991, pp. 70-82.

26 S. Selwood, 'Cultural policy and young people's participation in the visual arts', at http://www.psi.org.uk/news/youngart.htm (1997); emphasis added.

of the future to participate in 'high' culture. But this, more limited, form of emancipation is doomed to failure.

In post-Renaissance Europe, the gallery replaced the cathedral as the stage where a site-specific 'cultural capital' was employed to effect social exclusion. A post-industrial Europe is witnessing how 'cultural capitalists' are changing the playing pitch yet again to protect their privilege. If Bourdieu were to analyse the situation today, his book might well be called *L'Amour de l'Argent*, and deal with the stock exchange rather than the gallery. This new era may see the gallery become a politically harmless cultural stage for social play-acting, pursuing under-resourced policies towards a superficial cultural democracy. Visiting a gallery may be no more politically significant than going to church, an individualistic act of personal edification, thus reproducing good citizens allowed to live their private world-view in a designated public arena. Beyond the 'iron curtain', however, we have seen churches assume a new significance in the 'candle-light revolution' of 1989. Perhaps there are lessons here for the West?

developing the trust and confidence needed to bring an increasing number of groups into the Gallery. The concept of outreach was thus redefined, and an extensive programme of in-house educational opportunities was developed to sustain the community networks that had been so effectively established over five years. The emphasis was on creating workshops and courses, and arranging events and staff development seminars that not only sustained, but also further developed the relationship between the Gallery and particular communities.

The Education team had been discussing for some time the idea of a programme for young people, to take place at weekends or in the early evenings. The establishment of an informed consultative group, or Young Tate, enabled young people to become involved in the development of programme ideas aimed at young visitors between the ages of fourteen and twenty-five.

Through MAP the Gallery had gained an invaluable experience of working with young people in non-formal youth service settings. Having established links with voluntary and statutory youth services in Merseyside and the region, and with a history of Gallery-based work with schools and colleges, it was felt that the time was right to extend the Gallery's services for young people beyond the experience of a group visit. The move from MAP to Young Tate coincided with the Education Department's review of the role of outreach in relation to its in-house programming. MAP had become focused almost exclusively on the youth service as part of a strategy to introduce twentieth-century art to young people in their own time.

In 1994, the year Young Tate was set up, it was estimated that twenty per cent of young people between the ages of thirteen and nineteen participated in youth service provision. The percentage dropped to fourteen per cent between the ages of eleven and twenty-five.[1] In the same year, young people aged fifteen to twenty-four accounted for 25.4 per cent of all visits to the Tate Gallery Liverpool.[2]

[1] Percentages published in the *Statistical Bulletin*, DfEE (1995). For a current view of youth service provision, the DfEE has recently published *England's Youth Service – the 1998 Audit*.

[2] Figure drawn from visitor research commissioned by Tate Gallery Liverpool undertaken by Morris & Hargreaves, 1994.

THE ADVISORY GROUP

I'd been to workshops organised by the Education Department at the Tate through school, but even though I was studying art at A level, I can't say that I visited the Gallery in my own time. My reason for getting involved as a member of the Young Tate Advisory Group was sheer curiosity. Naomi (the Young Tate Co-ordinator) had come out to our school, and somehow she managed to convince me that giving up what turned out to be my entire social life would be a good thing.

Gary Clarke, Young Tate

The proposal to create a Young Tate Advisory Group was formally raised at senior management level. The concept was supported by the Gallery's Programme Planning Group, and included

a programme for young visitors, and an agreement for young people to select work for a Young Tate display scheduled for the end of 1995. As Young Tate was to replace MAP, the role of co-ordinating the Young Tate Advisory Group and the Young Tate programme for young visitors was taken on by the MAP Co-ordinator, who became the Young Tate Co-ordinator.

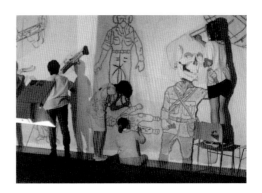

How young people were to be recruited to the Advisory Group, and a very real concern about the extent of young people's involvement in the curating process were still to be resolved. What was known was that for the programme to succeed, the sustained commitment of the young people recruited to the Young Tate Advisory Group was vital.

The Gallery decided the best way to recruit young people to the Advisory Group was to make use of links established with youth services and schools, particularly those made through MAP. Following much discussion, the Gallery decided to recruit using the following criteria:

- young people to be between the ages of fourteen and twenty-five;
- they, or the organisation they represent, to be based in Merseyside;
- they, or the organisation they represent, to have had previous contact with Tate Gallery Liverpool.

This strategy allowed us to target individuals who had some familiarity with the Gallery. We didn't want the group to consist entirely of art students, and the Gallery endeavoured to recruit young people from a cross-section of social backgrounds, and with a broad range of interests. By approaching organisations with which the Gallery had worked or liaised in the past, we were able to make use of existing links and ask for practical advice and support. This approach provided a way of gauging young people's potential level of commitment to what was essentially a long-term project. We were also advised to recruit approximately thirty young

people initially, and to expect the number to drop to about fifteen after the first two or three meetings.

On the issues of pastoral care and recruitment, initial discussions were held with officials from Liverpool City Youth Service and Merseyside Youth Association, the organisations who had collaborated with the Gallery on the Youth Arts Weekend.

It was decided to recruit young people from each of the five boroughs of Merseyside: St Helens, Knowsley, Liverpool City, Sefton and Wirral. The minimum commitment young people were asked to give was to attend a minimum of one meeting per month; any involvement beyond this was left up to them.

In St Helens, we approached Sutton Community High School; this school has strong links with the Gallery through its participation in the making of sculptor Antony Gormley's *Field for the British Isles* (1993), an artwork made up of more than 40,000 terracotta figures. Sutton High's Head of Art was enthusiastic about Young Tate, and agreed to recruit five young people from the school's year ten GCSE art group.

In 1992 MAP had commissioned Knowsley Youth Theatre to devise a performance in response to 'Natural Order', a display of contemporary sculpture from the National Collection. This particular MAP project contributed greatly to increasing the Gallery's understanding of how professional youth workers operate over a sustained period of time. It also gave young people and Gallery staff the opportunity to get to know each other over several sessions. Two years on, the Gallery wrote to all those who had taken part in the 'Natural Order' project, inviting them to a meeting to discuss Young Tate. Seven young people responded and 'signed up' for the Advisory Group.

The City area was represented by four young people recruited through photography projects run by Liverpool Anti-Racist Community Arts Association (LARCAA). In addition, one or two individuals later became involved from the City area having attended Gallery workshops with their school or college. The Bluecoat School enabled the Gallery

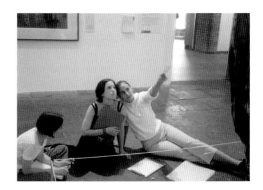

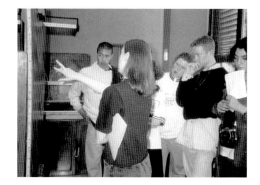

to recruit a further five young people from the City.

Young people from Yellowhouse, the group who had performed at the Youth Arts Weekend, were invited to represent Sefton. The response to this invitation was poor, with only one young person attending meetings. As the Advisory Group became established, more young people from Sefton were recruited through school and college workshops.

Wirral was represented by two young people from the Sanderling Unit, both of whom had worked with the Gallery on Brilliant Trees, a term-long project which responded to the work of Joseph Beuys. Three young people from Rock Ferry High School, the mainstream school to which the Sanderling Unit is attached, also became involved. The Gallery approached Wirral Youth Theatre with a view to interesting a slightly older group, and five young people were recruited.

Thirty-five young people attended the first Advisory Group meeting in April 1994, with a similar number at the second. By the end of the summer, about ten young people had dropped out completely, with the number of young people attending meetings fluctuating between ten and fifteen. The Advisory Group's attendance figures remained at around twenty-five throughout the first eighteen months.

One or two of the Young Tate members recruited through schools have since commented about the 'unfairness' of the selection process: in three instances, teachers were asked to select young people they felt would be interested in Young Tate, as well as able to maintain a commitment to it. At the time, this was the 'fairest' way of approaching young people through schools, given the limited number of places available, the Gallery's unfamiliarity with most of the young people themselves, and the limited time and resources available to recruit more widely.

Galleries have little, if anything, to do with visitors' travel arrangements, which are usually organised by group leaders or by the individual visitor. The safety and general well-being of the

young Advisory Group members was to be an entirely new area of experience for the Gallery, and pastoral care considerations therefore required careful planning, following advice from youth work professionals and teachers. The Gallery was required to obtain written consent from parents or guardians of those young people aged under eighteen. Consent was needed for them to become a member of the group, attend meetings at the Gallery, and visit other venues whilst in our care. (Of the thirty-five young people who attended the first Advisory Group meeting, two-thirds were under eighteen.)

Overseeing the safe return home of young people in Young Tate's early days absorbed a large amount of time and money: the Gallery allocated well over half the Young Tate budget to cover travel expenses which were considerable. For example, two young people travelled to the Gallery together by train from St Helens, a twenty-five mile round trip. When necessary, taxis were used, especially after meetings that finished late on dark winter nights.

The Gallery had no previous experience of a long-term project of this nature. The creation of the Young Tate Advisory Group brought with it new responsibilities, and presented new challenges practically as well as curatorially. The knowledge and experience gained of pastoral care during this period was to shape the Gallery's future youth policy, and add significantly to the Young Tate programme's sustainability.

The Calouste Gulbenkian Foundation funded Young Tate's 'pilot' year, 1994–1995. Funding for subsequent years was yet to be applied for, although the Gallery was committed to running the programme for at least three years.

Memories of the
Young Tate Advisory Group

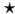

Soraya Lemsatef

No group of people can be said to fully represent a particular audience, and the Young Tate Advisory Group is no exception. Young people were drawn together on the basis of a link with Tate Gallery Liverpool, either as an individual, or as a representative of an organisation with connections to the Gallery. The following case study was written by Soraya Lemsatef, a founding member of Young Tate, in 1998. It reflects some of the views of those who took part in the original Advisory Group.

YOUNG TATE ADVISORY GROUP – OUR FIRST YEAR REMEMBERED
SORAYA LEMSATEF, YOUNG TATE

Although I didn't attend the first two Advisory Group meetings myself, I was interested in finding out what some of the young people remembered about Young Tate's first year, and what they thought they were getting involved in. I knew the original group very well, so I decided to interview my old mates over the phone and ask them some searching questions for this case study.

Interviews conducted between 17 August and 4 September 1998.

Did you have any preconceptions about the Tate Gallery? What were your thoughts when asked to join the Advisory Group?

Michelle O'Dwyer (MO): Very formal. Couldn't believe my luck. Really excited. Nervous about people being arty.

Lee Reid (LR): I worked out with them before. Not negative because I knew the educational activities they ran, therefore I knew the point of the exercise.

Sarah Jacobs (SJc): Bit apprehensive about what it involved but looking forward to it.

Gary Clarke (GC): Yes. Intimidating as a place, so I assumed the people [there] would be the same.

Paul Hammond (PH): All the usual stuff – intimidation, apprehension. I must've only been fifteen years old. It wasn't too bad.

Kerry Bagan (KB): I'd worked with the Tate when I was eleven, did an arts project, 'Natural Order'. I knew about the relaxed atmosphere and friendly people.

Sarah James (SJm): Quite excited. I'd always loved galleries, so I was intrigued.

Paddy Brown (PB): I heard we might be making an exhibition.

Describe how you felt at the first few meetings? What were your first impressions of the other young people?

MO: Started off very quietly, really excited about the whole thing. Everything was really quiet, people reluctant to join in. I felt I had to push my point across quite a bit at first. I was surprised about the mix of people.

LR: It was obvious that a lot of people were there for the wrong reasons. They'd heard about it and were intrigued but I knew what was going on.

SJc: You don't know anyone, don't know what's going to happen. It's a new thing. Mixed feelings. Sarah was there at least.

GC: It was easy because I was with four others from school. There were about thirty art students. I was chuffed that I had been asked to join.

PH: A lot of people in the group were snobby. We were school kids and everyone else was much older. It wasn't 'Young' at all. There were about sixty university students there.[1]

[1] Editor's note: of the thirty-five young people aged between fourteen and twenty-four who attended, none were at university, and only a small number were studying art above A-level!

KB: I remember halls of people. I thought everyone knew everyone else, knew everything about the Tate, except me. I also thought that everyone was a painter apart from me – so I didn't belong there. All the people were wearing 'studentie' clothes and there was me with my tracksuit and trainers. I felt that everyone knew why they were there, I didn't have a clue why I was.

SJm: It was quite confusing and ambiguous but it looked like it was going to lead on to interesting things. I thought the people there were a groovy bunch of young hip-cats.

PB: It was all right...a good bunch of people.

What did you expect Young Tate Advisory Meetings to be about? Do you remember any of the issues discussed?

MO: I expected the meetings to be boring like a school lesson. To sit there and talk about art. I was hoping that it wouldn't be boring and it wasn't. Young Tate was the best because there were so many different types of people. No one was classified, we all shared different types of energy. No one made anyone else feel categorised. Large personalities.

LR: Issues of ways of improving access to young people, getting rid of the pretentious image of the Gallery.

SJc: Discussing what we could do in the Tate. Young people's attitudes to art, helping out in workshops. How we could help the Gallery and in turn how they could help us. I think there was a small aspect about curating, but mainly it was about workshops.

GC: I thought it would be more about advising the Tate on how they could help us as young people so they could go off and implement our suggestions. Learning a tiny bit about the role of the Information Assistants, otherwise I thought we would be filling out questionnaires and conducting surveys.

PH: I can't remember any of the issues discussed. I expected to look around the galleries, discuss art historians. It was the first thing I'd done like that before so I went head in.

KB: I expected to discuss the image of the Tate, how we as young people saw it. I thought that they wanted to change their image and wanted a young person's view.

We went on tours of the building like the boiler rooms, which was irrelevant.
But I think the idea was to make us feel special because the public wasn't permitted there but we were.

SJm: I expected them to have more of an agenda but they never seemed to. It was minutes, apologies and biscuits. The Display was where it was at its most productive.

PB: Advising the group on how to make exhibitions.

Your role – how involved did you think you would be at the beginning?

MO: I thought that we'd go and be told what to do and choose, and what to say. I thought we'd be chaperoned but we had complete freedom, going in places like the 'stores'.

LR: I think that I wasn't overwhelmed but I was quite involved because I knew the people. I didn't expect much responsibility but I'm not a passive person so I got it eventually.

SJc: I knew I would have to dedicate a lot of time to it. I thought my role would be to tell more young people, try to get them to come to the gallery, spread awareness.

GC: We only met once a month so I thought I'd only be committed to three hours possibly twelve times within the space of a year. That's not much involvement.

PH: I thought I would be more involved than I actually was.
Me and Sandie weren't as involved because we weren't heard. That was our gripe.

KB: I thought I'd be useless – the silent one. Because I didn't like art I had no interest. It got to a point where I'd ask, 'What's this meant to be, like?', I'd ask then I'd learn.

SJm: I hoped to be heavily involved. I wanted meat, not just the Advisory Group, it wasn't actually consistent. No definite group structure with thirty people, different people attending every time. A sense of white board = bizarre objectives. No one was clear.
A load of drama games.

PB: I didn't think I would be that involved, partly my own fault for daydreaming.

58

Were you surprised with the amount of staff contact you had?

MO: I felt like I belonged there like I was part of the Tate. Waltzing in, grabbing a coffee, knowing faces. We could go anytime and talk to Naomi, loads of support from the staff.

LR: It is nice when you walk in and the Information Assistants say 'hello'.
It makes the Gallery seem like it has a human front.

SJc: Naomi and Fiona were good. Meeting them was like 'my goodness, a curator. Aaaaaargh!'
We needed someone who knew what they were talking about.

GC: I was surprised [with the intensity of staff contact] but the only people we actually had contact with were Naomi and a couple of Information Assistants.

PH: I was as comfortable as I could get in an institution. Naomi did her best. It would have been better to meet in a different environment – something smaller and more cosy.

KB: I felt special. When signing in and collecting my visitor's pass, I would try and get the public's attention because I could go in places where they couldn't and they didn't know what was in there. That was my favourite part, going backstage, meeting people, and seeing what went on.

SJm: We didn't exactly 'get down' with Lewis Biggs! A sense of ownership did develop but there was always the sense of we as the outsider. We got some snapshots of the Gallery and developments. It was nice to feel we were comfortable being in the Gallery, that did develop.

PB: I felt a bit of a tough guy. I thought it was silly to sign in and out. I stayed with the group because I liked everyone and wanted to make the exhibition work – something that young people would like.

Did committing to the group have any adverse effects on your social life or did it expand it?

MO: It expanded it. My personality changed, I chilled out a lot, it was good mixing with people with different tastes because I picked up on a lot of mixed music
I would have never previously got into.

LR: Positive. I made new friends, although it was bad coming in on Saturdays when I had an appalling hangover!

SJc: Difficult question. It did expand it because we went out socially, but there were other times that we had to give up things, but meeting others made it worth it.

GC: It didn't have an adverse effect on my social life but it didn't really expand it either. It was a hindrance to have to get up and go to the meetings.

PH: No, it was only a weekday night. I wouldn't say committing to the group expanded my social life. London trips were cool!

KB: It expanded it because, being in school, I didn't have much of a social life anyway.

SJm: It was nice, it did feel nice. 'Karmadrom' with Paddy, lots of social events.

PB: Expanded it, invited to lots of Private Views and a boss bunch of people.

How did you explain what you were doing as an Advisory Group to your friends and family?

MO: Simplest way was to say I was doing voluntary work. Everyone knew though because I brought them along to Private Views. A lot of my arty friends were studying art and they envied me. I was really chuffed.

LR: I did a presentation as part of a job interview to get myself a job as a chemical engineer. (As a demonstration of outside interests and activities.) A lot of my friends were well into it. I thought that the Tate brought us in to get an outsider's view that isn't constricted by the institution. You supposedly go in with a fresh new perspective before learning the rules. However, rules are a large part of it, and you eventually become part of the workings of the machine.

SJc: I just said I was doing work in the Tate Gallery. Nothing else.

GC: I didn't really mention the Advisory Group. I wouldn't have stuck with it if it hadn't have gone on to better things (i.e. the Display Group).

PH: Yes, I admitted being involved; everyone at school knew what I was doing. 'I go the Tate Gallery.' It was easier towards the end of the Display Group because we were doing something. At the beginning, I said we were doing a workshop or something. I didn't go into much detail.

KB: I said that I was helping to pick out an exhibition to help portray a young person's point of view.

If you could get involved in Young Tate again, would you have had a different attitude?

PH: I would have put a lot more in. Made myself heard more.

KB: Put my foot down more, shoved my neck on the line.

SJm: I feel guilty because I didn't have time for both the Display Group and the Advisory Group. I feel people were resentful because we were in the 'clique'. The Advisory Group met to be informed about the latest developments of the 'other' [elite] group. There was an elite number. A hell of a lot of commitment still, different people now, the original group didn't work. The problem was, the Advisory Group didn't have a history. First the Advisory was born, and then a few months later the Display Group was formed. So it was as if the Advisory was like a selection group for the Display. It had no history, it needed background, support – loads. It needed its own constitution.

PB: I would have changed a lot. [The Gallery] didn't listen much. People inputted a lot of creative ideas but they weren't even considered. Grown-ups were trying to get us to 'grow up', but we were still young people.

Has the experience changed your attitude towards galleries
(or perhaps your own direction in life?)

MO: Before I worked with the Gallery I didn't know what I wanted to do. I was very quiet but [the experience] brought me out of myself. I stood up for myself. I want to work with people. Due to the Tate, I want to be a youth worker. Now I am a good talker, and I want Naomi's job!

LR: It has made me realise what an uphill struggle it is to curate an exhibition –
the advertising, organising events around it, getting people in to see it.
But it hasn't changed my direction in life.

SJc: Yes, definitely. I thought galleries were strict. Upper-class places that people couldn't go
in unless you were an art student. If you weren't then, I thought, you weren't welcome.

GC: Now I understand more how a gallery works but I still don't go in them.

PH: Because the Tate is so different from other galleries, it is hard to compare.
The Walker is a whole different field. It is more to do with the staff.
Other galleries are not as awkward; the staff are more laid back and lazy.
It is nicer elsewhere, less clinical. It is really intense at the Tate.

KB: Yes I suppose the experience has changed my attitude towards galleries.
I would take time now to go and see them, especially if I was in another country
or somewhere new. I was always mature before my age but mixing with new people of
different ages, backgrounds, cultures and experiences had a profound effect on me.
I now buy cheese and lettuce, and joss-sticks and candles! Also, I'm not in prison and
haven't had a baby like my mates. I'm going to University to study Drama Therapy,
me... Kirkby-Girl!

SJm: A bit. It has given me an insight behind the scenes of a display.
But I liked galleries before. It has changed my personal direction in the curatorial aspect
because I'm studying art history now. Galleries are calming, inspiring places.

PB: I realised how snobbish galleries were, but I never saw it from the inside.
I never realised to what extent.

ESSAY

Museums, Galleries
and the Business of Consulting
with Young People

Sara Selwood

[1] A. Coles, 'Widening Access to Museums. Pressures for Change', unpublished MA thesis (London: City University, Department of Arts Policy and Management) 1994.

[2] S. Davies, *By Popular Demand. A Strategic Analysis of the Market and Potential for Museums and Art Galleries in the UK* (London: Museums & Galleries Commission) 1994, p. 36.

[3] K. Mathers, *Museums, Galleries and New Audiences* ed. Sara Selwood (London: Art & Society) 1996, p. 16.

[4] S. Hogarth, K. Kinder and J. Harland for the National Foundation for Educational Research, *Arts Organisations and their Education Programmes* (London: Arts Council of England) 1997, p. 82.

Almost all museum mission statements written in the 1990s pay lip-service to widening access and improving opportunities for life-long learning, and many museums aspire to a visitor profile representative of the general population.[1] While visitor profiles vary considerably from museum to museum, overall people aged between sixteen and twenty-four are amongst the least likely to go.[2] Museums and galleries have recognised them as more poorly represented amongst their visitors than any other group.[3] Moreover, visual arts organisations are less likely to target the youth service than most other types of arts organisation.[4] In an attempt to remedy this, over the past decade museums and galleries appear to have become increasingly concerned to attract more independent young visitors – those

visiting without education or other organised groups.[5]

Although art museums and galleries tend not to keep detailed records of their education work, various aspects of their relationship with young people have been examined. Published reports include case studies of individual projects[6] and examinations of young people's attitudes towards the institutions themselves.[7] But to date little is known about how such institutions either seek or act on the advice of young people in the setting up of their programmes. This paper considers both issues. It examines why art museums and galleries target young independent visitors, how art museums and galleries set about attracting young people, and the results of those efforts.

[5] J. Harland and K. Kinder, *Crossing the Line: Extending Young People's Access to Cultural Venues* (London: Gulbenkian Foundation) 1999.

[6] S. Selwood, S. Clive and D. Irving, *An Enquiry into Young People & Art Galleries* (London: Art & Society) 1995; S. Rider and S. Illingworth on behalf of Artswork, *Museums & Young People* (London: Museums Association) 1997.

7 J. Harland, K.Kinder
and K. Hartley, *Arts in
their View. A Study of
Youth Participation in
the Arts* (Slough:
National Foundation
for Educational
Research) 1995; J.
Harland, K. Kinder, K.
Hartley and A. Wilkin
for the National
Foundation for
Educational Research'.
*Attitudes to
Participation in the
Arts, Heritage,
Broadcasting and
Sport: A Review of
Recent Research*
(a Report for the
Department of
National Heritage,
undated); Harris
Qualitative *Children
and an Audience for
Museums and
Galleries*, prepared for
the Arts Council/
Museums & Galleries
Commission, 1997.

WHY YOUNG PEOPLE ARE A MAJOR TARGET FOR ART MUSEUMS AND GALLERIES

There are any number of reasons why galleries might want to attract young people outside formal education – a group whom they may have previously neglected.

Museums and galleries are, by definition, educational institutions. Many were established in the nineteenth century with education at the heart of their brief, and were regarded as contributing to the social and economic well-being of the nation. It is generally assumed that education is fundamental to the visitor experience, and that by definition visitors learn as a result of going to cultural institutions. Increasing access is thus taken to be synonymous with education in the broadest sense.

Several other factors contribute to museums' current concern to improve access. These include financial necessity, social responsibility, increased accountability and the drawing up of performance indicators. A trend towards professionalism since the late 1980s has also encouraged museums to find out who their visitors are, as well as encouraging them to enquire into 'non-users'.

Art museums and galleries are, however, not always explicit about their intentions in working with young people. Yet studies of individual projects suggest that their motives involve audience development, as well as the delivery of specific art educational goals, such as 'de-mystifying' particular twentieth-century and contemporary artworks.

Museums and galleries' concern with young people implicitly also refers to more general educational objectives: instilling in them the habit of life-long learning; securing their right to a sound education; creating good citizens; and, to a lesser extent, fostering the country's future workforce.[8] Institutions often describe projects as intended to 'empower' participants, and increase their confidence. It could be argued that this is essential since young people are considered to have borne a disproportionate burden in the economic restructuring of Britain over the past twenty years, with significant numbers being beached by the transformation of the labour market.[9] It may be indicative of such concerns that many, if not the majority of art gallery projects for young people are targeted at those who might not otherwise have access to the art, who are from minority groups, are unemployed or homeless.[10]

Such concerns also reflect the impact of recent cultural policies at the local, regional, national and supranational levels. The present government, like its predecessor, credits cultural policy and cultural institutions with an extensive capacity to nurture this particular group.[11] Even the United Nations' Convention of the Rights of the Child, ratified by the UK government in 1991, champions the right of young people to participate fully in cultural life and to express themselves through the arts.[12]

8 D. Anderson,
*A Common Wealth.
Museums and Learning
in the United Kingdom.
A Report to the
Department of
National Heritage*
(London: Department
of National Heritage)
1997, p. 1ff. (second
edition for Department
of Culture, Media &
Sport 1999).

9 National
Organization for Adult
Learning/National
Youth Agency, 'Young
Adult Learners Project',
1997 (flyer).

10 Selwood et al.,
Enquiry, p. 78.

11 S. Selwood,
'Cultural Policy and
Young People's
Participation in the
Visual Arts', in *Journal
of Art & Design
Education*, 16.3, 1997.

12 Children's Rights
Development Unit, *UK
Agenda for Children.
A systematic analysis
of the extent to which
law, policy and
practice in the UK
complies with the
principles and
standards contained in
the UN Convention of
the Rights of the Child*
(London: Children's
Rights Development
Unit) 1994.

HOW ART MUSEUMS AND GALLERIES SET ABOUT ATTRACTING YOUNG PEOPLE

There is no comprehensive account of the various types of projects that art museums and galleries provide for young people. In fact, it appears that galleries rarely target young independent visitors. Several assume a *laissez-faire* attitude toward young people; some initiate schemes for young people, but confine them to outreach, and others provide one-off activities.[13]

The nature of art museums' enterprises for young people is largely determined by institutional priorities, by the individuals within the institutions who assume responsibility for young people, and by the enthusiasm of individual members of staff. In practice, such initiatives are usually driven by education, community or outreach staff. Yet, much of the effort devoted to attracting young people is better defined as marketing. The two are closely related.

The vast majority of projects for young people focus on their participation, and involve discussions and workshops – often led by artists – in which they can develop practical skills. These practices are driven by a combination of education and youth service approaches that favour direct involvement, with interaction as a key premise of learning, and peer-led activities. These may or may not be intended to equip participants to make choices about gallery going.

A smaller number of projects appear intended to attract more independent young

visitors to art museums and galleries. Few, if any, exhibitions are specifically targeted at a youth market, but galleries will involve young people in curating exhibitions, in leading related activities intended to attract their peers, and in helping to develop the quality of young visitors' experiences to the extent that they should encourage return visits.[14]

In their attempts to attract young people, art museums and galleries increasingly appear to be consulting youth workers, as well as young people and children themselves.[15] Their objective is to seek information, advice, opinions, permission or approval from these target constituencies.

In the context of general concerns about democracy, accountability and openness, this practice reflects the wider tendency of public service bodies to refer to their users and potential users.[16] Consultation is in many respects regarded as a tool to improve decision making and, by association, improve services. It can enable service providers to find out about the needs and preferences of users or potential users; reveal dissatisfactions and other problems with services; raise the profile and status of the institution involved and the issues about which they are consulting; provide the public with a means of voicing their feelings; and lend authority to decision making in a wide variety of contexts. It may even improve the internal workings and culture of the consulting organisation.[17]

Museums and galleries' practice of consulting youth workers or young people themselves is understandable, given the

13 Selwood et al., *Enquiry*, p. 11.

14 Selwood et al., *Enquiry*; Rider and Illingworth, *Museums & Young People*; A. Tilley, *Between the Eyes* (Oldham: Oldham Art Gallery) 1997 (mimeo).

15 B. Verge, 'Through the Eyes of a Child', *Museums Journal*, October 1994; S. Marwick, 'Out of the Mouths of Babes' *Museums Journal*, October 1994.

16 See, for example, J. Gordon and V. Griffith, 'A National Poll for Children', in *The Library Association Record*, 99 (7) July 1997.

17 J. Seargeant and J. Steele, *Consulting the Public. Guidelines and Good Practice* (London: Policy Studies Institute) 1998.

constraints under which they work. Projects which galleries organise for young people are unlike their schools' provision in that they typically involve small numbers, and consume a disproportionate amount of time and resources on the part on the institution. In the case of Young Tate, the expenditure was seen as an investment in the long-term development of youth programming at the Gallery.

Art museums and galleries are disinclined to invest in projects without guaranteed attendances, and so they often exploit contacts that already exist between gallery staff and youth workers, who can be relied upon to provide participants for projects. Indeed, some projects are strategically designed to develop such relationships, and are often tailored according to youth workers' representations of the 'needs' of their young people.

Recent examples of museums, galleries and related bodies directly consulting young people – attenders and non-attenders – include projects based at Oldham Art Gallery,[18] across a consortium of museums in Sussex,[19] as well as at Tate Gallery Liverpool. These were concerned to discover: what would bring young people into museums; how the quality of their experience might be improved, with a view to encouraging return visits; what kind of promotional material would attract them, and how it should be distributed. The Museums & Galleries Commission and the Arts Council of England have also commissioned research into what provision children aged seven to eleven, and their parents/carers, felt would encourage

attendances to museums and galleries, and how such provision should be marketed.[20]

Young people who are not attenders were found not to have felt themselves alienated from art museums and galleries, but merely thought that they would hold nothing of interest for them. Although first-time visitors expected art museums to be dull, in the event they found that the art museums were 'not as boring as you might think'. However, they wanted to be made to feel welcome, they wanted the cafés to be cheaper, and they wanted betters signs and orientation: 'the art museum is like a maze'. They also wanted better quality displays: 'as you go upstairs it's all brown – yuk', and less text-based information, better presented. Labels were criticised as being 'old and falling apart – it looks as though the museum doesn't care much', and as being poorly placed: 'too high'. Like other visitors, they wanted a greater degree of comfort: 'it's a shame there's nowhere to sit down and talk about exhibits'. Other requirements included music in the galleries, more information in the form of 'statements from artists' and 'audio-guides made by young people'. They also wanted access to the people involved: 'to meet artists' and 'other people working in the museum'.[21]

WHAT RESULTS DO THESE EFFORTS PRODUCE?

If there is a dearth of studies about art museums and galleries consulting young people, there is an even greater paucity of information about

18 Tilley, *Between the Eyes.*

19 K. Fowle, 'SCRATCH. Free your mind and your art will follow', a project conducted by young people for young people to raise awareness of museums and art galleries in Sussex. Report for work conducted in the project September 1976-June 1997 (mimeo) 1997.

20 Harris, *Children.*

21 Fowle, 'SCRATCH'; Tilley, *Between the Eyes.*

how those institutions use the information they gather, and to what effect. Some accounts exist as to how young people involved in curating exhibitions influenced the selection of artworks and their presentation.[22] But there are no descriptions of how any of these consultations have contributed to art museums and galleries' longer-term attempts to change their visitor profiles, or to increase the 'user-friendliness' of the culture of the institutions themselves.

The following section raises some of the questions that arise from art museums and galleries' involvement with young people, as it appears in the published literature on the subject. It touches on:

- whether the category 'young people' is as useful as it is assumed to be;
- whether by investing in small core groups of young people over a sustained period, institutions are better able to increase attendances by young people in general and to excite their interest in art;
- whether youth workers share museums' and galleries' ambitions of increasing attendances by young people;
- whether the procedures employed before or after consultation are sufficiently rigorous for the consultation to make a difference.

Records of art museums and galleries' consultations with young people suggest that their requirements largely concur with those of adult attenders and non-attenders.[23] Indeed,

Willis, who has written extensively on the cultural activities of young people, regards them as merely supplying 'many of the most graphic examples of cultural activity' and believes that his 'basic argument is relevant to cultural activity and cultural provision in general'.[24] From a young person's perspective, Fowle suggests, the category 'young people' may be patronising to those who 'simply see themselves as people and believe that their opinions and awareness of larger issues are as relevant as any adult:[25]

> Even within the 16-25 age range there are people who have been married, divorced, had children, lived independently, governed their own finances, experienced emotional and physical discrimination through unemployment and the work place, made decisions over their education and their future. They have a keen awareness of professionalism and informed views on local politics etc. Young people don't want to get involved in groups where they feel they are being treated as less than adults. They don't want to have their time filled.

There is, of course, always the issue of the young people possibly being older than the curator involved in their projects.

The general orthodoxy suggests that 'a key factor in [young people's] successful involvement is sustained and on-going support and encouragement'.[26] But, by definition, this

22 J. Hughes, *Ethnographic Study on Aspects of the Young Tate, Liverpool* (University of Liverpool, Institute of Irish Studies) (mimeo) 1996; Rider and Illingworth, *Museums & Young People*.

23 V. Trevelyan (ed.), *'Dingy Places with Different Kinds of Bits'. Attitudes Survey of London Museums amongst Non-Visitors* (London: London Museums Consultative Committee) 1991.

24 P. Willis, *Moving Culture: an Enquiry into the Cultural Activities of Young People* (London: Calouste Gulbenkian Foundation) 1990.

25 Fowle, 'SCRATCH', unpaginated.

26 Harland et al., *Arts in their View*, p. 279.

- to work with the Young Tate Co-ordinator to help plan and run a programme of events for young people and youth workers, focused on the gallery's exhibition and display programme;
- to encourage and support equal opportunities in all Young Tate's activities irrespective of gender, race, disability, age or sexuality;
- to document and evaluate Young Tate.

During the first three to four months, membership of the Advisory Group levelled off as the young people adjusted to the Gallery and prioritised their involvement with regard to their education, work and social concerns. The minimum commitment to the Advisory Group was to attend one meeting per month. Further involvement in workshops, projects or events was up to the individual. Travel expenses were paid for all Young Tate-related activities.

There was understandably concern about the extent to which young people would become involved in the day-to-day operation of the Gallery. An initial sticking point was the proposed regular monthly meetings, all of which would take place in the evenings when the Gallery was closed to the public and staff had finished for the day. The Gallery acknowledged the need for a more flexible approach to 'out of hours' work with members of the Advisory Group. The introduction of a programme of weekend workshops aimed at the Gallery's wider young audience also set a new precedent: regular activities at weekends for young people, families and adult groups are now a permanent feature of the Education programme at Tate Gallery Liverpool.

Young Tate Advisory Group meetings were run, at the request of the young people, as friendly but formal affairs. The meetings took place on the evening of the fourth Thursday of every month, moving to Sunday afternoons as the winter nights closed in. A chair was elected at the end of each meeting to preside over the next, an agenda was prepared with the chair in advance of the meeting, and notes were taken by a member of the Group.

The meeting provided an opportunity to let the Group know about forthcoming exhibitions, private views, and events taking place at the Gallery. Several Young Tate members attended the 1994 regional Turner Prize debate held at the Gallery, and young people became regular attendees of private views, so often the exclusive domain of adults.

Young people who attended events presented short reports about Gallery activities they were involved in. A regular agenda item would be a report on the most recent Young Tate workshop, from the team responsible for helping to plan and lead it with a freelance artist and the Young Tate Co-ordinator. Following this item, young people volunteered themselves to help with the next workshop, and a date for planning the session with an artist was set.

A talk by a member of the Gallery's staff was often scheduled into the meetings. The Gallery's Senior Technician met the Group and escorted them to areas of the building where artwork is handled before and after it is shown in the Gallery. At one of the first Advisory Group meetings the Group met Lewis Biggs, Curator of Tate Gallery Liverpool, who explained the Gallery's aims, and discussed some of the displays and exhibitions.

At the first meeting, the Gallery's Senior Information Assistant talked to the Group about the issue of safety for both the public and the artwork. He described the dual role of the Information Assistants, whose job it is to inform visitors about the work on display, as well as to ensure the security of the art and the building. The Group were given a tour of the building, and on their return they quizzed the Senior Information Assistant and members of his team about access to the Gallery for young people, and their attitudes towards young visitors. In response to young people's interest, and to give a better insight into the role of front of house staff, a small team of young people were invited to 'shadow' information staff as they went about their duties on an average day. This 'shadowing' project was one of a number of examples where the young people were introduced to the workings of the Gallery.

Small teams of young people became involved in projects, usually working with Gallery staff, which allowed them to research various aspects of the Gallery's work and then report back to the rest of the Group at an Advisory meeting. Three young people met with the Gallery's Press Officer and a freelance graphic designer to discuss the brief for a flyer aimed at promoting the Young Tate weekend workshops. This flyer successfully raised the profile of Young Tate, attracting significantly higher numbers to the workshops.

In September 1994, some members of the Advisory Group chose to commit even more time to Young Tate by opting to become part of the Display Group. This initiative is discussed fully in the next section of this book. Regular updates on the progress of the Display Group were given in Advisory Group meetings.

During this period, from September 1994 to February 1995, members of Young Tate Display Group visited the Tate in London on four occasions. The young people remarked upon the size of the gallery at Millbank, and the stylistic and atmospheric differences between the two galleries, and were starting to make sense of the Collection they had heard so much about, the vastness of which was becoming evident.

PROGRAMME FOR YOUNG VISITORS

Young Tate workshops for young visitors originally took place on the fourth Saturday of the month, moving to the fourth Sunday to accommodate Advisory Group members with Saturday jobs. All workshops used the Gallery's displays and exhibitions as a starting point for engaging young people with the ideas and issues raised by twentieth-century art. Workshops were free (except for those held in paying exhibitions where a concessionary ticket price applied), bookable in advance and open to all young people aged fourteen to twenty-five. Aimed at individuals or small groups, sessions were led by a Young Tate workshop team that included up to four Advisory Group members, a freelance artist (writers and performers have also been involved), and the Young Tate Co-ordinator.

Young Tate's workshop methodology grew out of the Education department's broader policy of encouraging the development of visitors' knowledge and understanding of twentieth-century art. Workshops across all programmes focus on discussion mediated through direct engagement with artists' work, with the aim of encouraging young people to connect the art in the Gallery with their own interests and experiences. The idea that people draw on their own experiences when involved in critical engagements with the ideas and issues raised by modern art underpins this approach. Participants do not have to be 'good' at art, or studying art to attend. The role of Young Tate – working with artists within a wider youth audience – went on to establish a culture of peer-led work within this methodology.

Four Young Tate Advisory Group

members and the Young Tate Co-ordinator met the participating freelance artist two weeks before a workshop was scheduled to take place. Where possible, the young people visited the artist's studio and were introduced to the artist's work. Ideas about the display or exhibition on which the workshop was to focus were also discussed at this stage. The second planning session took place at the Gallery where the workshop team discussed their ideas and responses to the work, agreed on the structure of the session and assigned individuals to lead specific parts of the workshop.

Young Tate workshops during this period lasted a full day, taking place within the exhibition or display, and in the education studio where any practical work was carried out. The aim of the sessions was to facilitate young people's understanding of what they saw in the Gallery, encouraging them to voice their ideas about issues raised by artists' work. Practical studio work – more akin to research than to the production of a finished piece of work – extended these responses, allowing young people to experiment with new ideas and materials, exploring further the content of the work in the Gallery. Depending on the nature of the art in the Gallery, this may have involved sculpture, printing, drama, writing, and so on. An informal feedback session was led by Young Tate facilitators at the end of every workshop. Participants were asked to discuss their thoughts about the workshop, its structure, the Gallery activities and whether they felt their understanding of the exhibition or display related to their practical work. Responses from participants were always forthcoming; the complimentary tempered by the critical. This feedback was helpful in planning future workshops, as well as providing a way for Young Tate facilitators to represent young visitors' ideas at Advisory Group meetings.

Sculptor Gary Perkins, whose early work involved the use of mass produced, sometimes 'kitsch' objects – cheap plastic toys, computer games, and components of CCTV surveillance equipment – led a Young Tate workshop on 'Moral Tales: art from the 1980s', a Collection display concerned with the impact of social and political issues on artists' work. The display

and events related to the Young Tate display had also been agreed as part of this budget. The introduction of fees was to set an important precedent. Young Tate members were developing specialist knowledge of the work in 'Testing the Water', coupled with a unique 'outsider's' view of the curating process.

The Advisory Group felt the weekend workshop programme for young visitors had been successful. They commented positively on the experience of working with freelance artists, and the enjoyment of leading sessions with other young people. Feedback from young people attending the workshops suggested many of them wanted the opportunity to spend more time in the Gallery, perhaps as part of a project over a period of days. Projects for the Easter and summer holidays were initiated as part of the programme for the following year.

Young Tate's second year, 1995, was an intensive and very rewarding period, during which the Gallery came to understand the need for flexibility and change in response to regular evaluation. A close working and social relationship with the Young Tate Advisory Group had been established, supported significantly by the intensive nature of the work carried out by the Display Group. It was during this second year that a clearer philosophy linked to peer-led work and programming began to take shape.

The Advisory Group continued to meet every month and membership stood at twenty-three young people, most of whom had been involved with Young Tate from the start. Some of the original members had dropped out over the year, several beginning college courses or starting work. New members were recruited through the programme of events, their fresh ideas and enthusiasm acting as a balance to the experience of the more established Group members.

These young people were now able to advise the Gallery and contribute to the Young Tate programme more effectively, informed by their knowledge and understanding of the institution. The Advisory Group, as individuals and as a whole, was becoming confident enough to be constructively critical of Young Tate. The 'closed' nature of the Advisory Group was debated, with young people voicing their concern that the Group might be viewed as an exclusive club, or a 'clique'. The feasibility of extending the group was discussed, to make it more representative of a wider range of young people. Budgetary limitations ruled out increasing numbers, so the closed membership issue was approached from another angle. It was proposed that the Advisory Group should continue to operate in its current form, but opening up membership to Young Tate to any interested young person aged between fourteen and twenty-five.

The Advisory Group decided that Young Tate membership would involve becoming part of a free Young Tate mailing list, targeted specifically at young people as individuals. Marketing

of Young Tate, and of the Gallery as a whole, had been one of the Advisory Group's main criticisms. A dedicated Young Tate leaflet detailing the Gallery's exhibitions and displays, special events and forthcoming workshops and projects would be mailed to members. The leaflet would also be available in the Gallery, and sent to youth organisations, schools and school magazines. The regular programme of weekend workshops linked to the Gallery's displays and exhibitions continued, firmly establishing an ethos of peer-led activity.

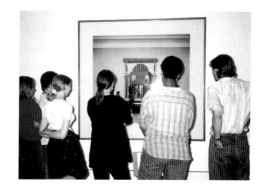

September 1995 saw the opening of 'Testing the Water: a Collection display selected by Young Tate', the project delivered by the Young Tate Display Group which is covered in detail in the next chapter. Wherever possible, school, college or work commitments notwithstanding, Young Tate members were involved in helping to plan and run programme in and around this display. All those involved in this programme were paid a fee set at £5.00 per hour.

Sessions Young Tate members helped to facilitate included:

- outreach work with a residential school, which led to two workshops taking place at the Gallery with the Young Tate member and an artist;
- three In-Service training courses for teachers;
- an Open Evening for youth workers hosted by a group of young people;
- two First Saturday workshops for adults;
- two Young Tate workshops;
- two afternoons working on the Gallery's family programme, the Great Art Adventure.

The Advisory Group was able to try out a new approach to visitor interpretation through a series of 'animated talks', called Taking the Plunge, which took place in the 'Testing the Water' display on one Sunday afternoon per month for the duration of the exhibition, attracting

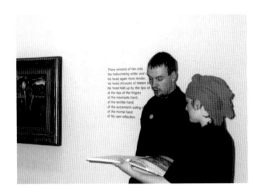

audiences of up to fifty Gallery visitors. Several members of the Group worked with a drama specialist to devise and deliver these talks to the public. The young people developed responses to several works in the display: William Turnbull, *Idol 2* (1956), *Idol 4* (1956), *Queen* (1987) and *Transparent Tubes* (1968); Reg Butler, *Musée Imaginaire* (1961–63); Gwen John, *Nude Girl* (1909–10); and Salvador Dalí's painting and poem, *Metamorphosis of Narcissus* (1937).

As part of this series, two female members of the Group devised a powerful and disturbing response to works by Reg Butler and Gwen John. They felt Butler's *Musée Imaginaire*, a wall-mounted cabinet filled with small nude female figures cast in bronze, and Gwen John's *Nude Girl*, a painting of a naked teenage girl, raised issues regarding the representation of the female nude and the artist's relationship with the model.

Within the regular Young Tate programme, newly introduced holiday projects proved to be an ideal way to develop and explore ideas around an exhibition. Lasting two or three days, the projects provided enough time for young people to get to know each other, the Gallery and the art on show. They also allowed groups travelling some distance the opportunity to combine their visit with a residential stay in Liverpool. Youth groups from as far afield as Lancashire, Barrow and Shropshire participated in the Easter and summer holiday projects during 1995.

The first of two summer projects took place in July towards the end of the school term. Around twenty-five young people and three youth workers spent two days with photographer Leo McDonagh and Young Tate members, exploring ideas around the display 'Witness: photoworks from the Collection' (see case study). During three days in August, drama and sculpture were used to respond to the exhibition 'Making It: process and participation'. Young people worked with a drama worker and an exhibiting artist, developing ideas and investigating the issues drawn from the artworks in the display.

Reviewing Young Tate's second year, the Advisory Group examined the weekend

workshop programme's impact and ability to make the Collection accessible to young visitors. The workshops had proved a successful and popular way of engaging young people with a particular display or exhibition. However, having recognised workshops as valuable and enjoyable experiences, the Advisory Group and the Gallery were conscious that workshops have their limitations. The following points were raised by Young Tate members involved as facilitators of workshops, and by Gallery staff:

- the maximum number of participants is twenty-five;
- some young people are put off workshops because they are reluctant to commit themselves to a day-long activity;
- workshops imply practical activity, which many young people associate with technical skill and being 'arty';
- the boredom/reverence associated with galleries remains a fundamental barrier in attracting young people;
- without regular, high profile marketing attracting new participants, the workshops run the risk of becoming an art club for regular attendees.

These concerns led the Advisory Group to trial a drop-in activity to replace weekend workshops. Drop-ins were seen as more informal sessions that offered a variety of options for investigating a display or exhibition, ranging from gallery activities and practical making to discussion and self-study areas. A more intensive, workshop-style activity would continue to be offered in the form of two- or three-day projects during the Easter and summer holidays.

CONCLUSION

The commitment and interest of around two-thirds of those recruited to be members of the Young Tate Advisory Group has proved to be long-term, and several factors seem to have contributed to maintaining the Advisory Group's interest throughout Young Tate's first year and well into its second:

- a clearly understood role for the Advisory Group;
- establishing the minimum level of commitment from members;
- the chance for members to become more proactive within the weekend workshop programme for young visitors;
- the chance to become involved in the selection of work for the Young Tate display.

It seems unlikely, however, that this commitment would have been sustained if the Gallery had not paid the young people's travelling expenses.

The establishment of a dedicated post to co-ordinate Young Tate served to strengthen and support an evolving approach to developing a programme for young audiences. Through the Young Tate Advisory Group, the Gallery's response to a new and somewhat experimental youth programme was flexible and creative. Young Tate is an ongoing process of consultation – a partnership between young people and the Gallery. The early realisation of the value of peer-led education in the planning, teaching, evaluation and dissemination of Young Tate's activities has been the key to ensuring the programme's successful integration into the culture of the Gallery.

Two-day
Summer Project
July 1995

Gary Clarke

I was one of three Young Tate members involved in helping to lead a two-day summer project based around the display 'Witness: photoworks from the Collection'. The show included works by Cindy Sherman, Gerhard Richter, Paul Graham, Tim Head, Boyd Webb and Barbara Kruger.

As with any Young Tate workshop we met an artist, a photographer called Leo McDonagh, and visited his studio to find out about his work. During this visit, and later in the display, we talked about ideas for ways to work with the show, discussing themes, our own feelings about the images, and how to approach the Gallery's practical problems, for example, it doesn't have a darkroom which is essential to a photographer. We then planned the structure, deciding on how each of us would lead different activities over the two days. For example, two young people led ice-breaking games on the first morning, then we each led small groups in the 'Witness' display, helping to get the group to discuss their ideas about the work.

Young people went on to experiment with these ideas by using photomontage – putting together images from magazines and re-photographing them using Polaroid 'instant' slide film. This meant that the group were able to produce practical responses quickly, allowing them to take the process and their ideas further the following day.

The next day everyone worked in small groups, returning to the display to re-visit the work and talk about some of the issues it raised. The young people then went back to the studio space and, using 'instant' slide film loaded into SLR cameras, began to try out ideas based on

their responses to the work. Leo had shown Paddy and me how to put the finished slide film through the Polaroid processing unit set up in the studio. We helped the young people to process their slide film and showed them how to make up slides.

Towards the end of the second day, young people presented their work to the rest of the group. About thirty young people attended the project – most came from Merseyside, but there were also groups from Shropshire and Lancashire. The young people were aged from fourteen to twenty-five, but the age range didn't seem to be a problem. Seeing a young person leading parts of the project helped to build people's confidence; it helped to make everyone seem more comfortable about saying what they thought about the work in the Gallery.

Integrated Management

Gaby Porter

Who gives meaning in museums? In the traditional paradigm, museums were didactic, delivering knowledge and meaning. The museum's staff, as acknowledged experts, provided objects to be viewed and knowledge to be acquired and absorbed. Museum professionals sifted and weighed evidence behind the scenes, but presented firm and authoritative statements to the public. Despite museums' commitment to education and learning, in this paradigm they did not nurture and promote a truly enquiring spirit among their publics. The corollary of this in the internal organisation of museums was a hierarchical and divided structure, where each department, section or individual acted separately and more or less autonomously, and others were exposed to the impact of decisions

and actions in which they had not been involved. Staff understood their role as that of protecting and defending their discipline or department – their 'own patch'. Certain jobs (those at the centre, those close to collections and more distant from the public) carried more status than others (front line staff in attendant and education posts, close to and in immediate contact with the public). The success of a project lay in the product, rather than in the process of its production or the outcome/effect on its public.

In the new paradigm, museums are centres for personal learning where people create their own meanings: self-directed, informal, inclusive, and developed through social networks rather than formal educational organisations. Museums are rich and abundant

in resources and materials; they are informal public spaces where people can learn with and from each other, objects and environments in an active, participatory and experiential way. In this paradigm, museums stimulate dialogue and enquiry, encouraging and enabling the people who use them to attribute their own meanings to collections and histories, and to seek truths for themselves.[1] This changes the relationship between museum professionals and the museum public. Professional expertise is accountable to, and dependent on, the common understanding of the community.[2] The corollary of this is a managerial framework co-ordinated rather than controlled from the centre: localised, outward-looking and responsive, sharing and offering greater responsibility and opportunity to staff at all levels. Staff begin to think and act from the perspective of the whole unit or organisation, retaining responsibility for their own work area *and* becoming part of the larger picture. Here, the success of an individual project lies in many elements: the process of its production, the completed project, its outcome/impact on those who it is intended to reach, and the learning which comes from it.

Metaphorically, therefore, the boundaries of the museum change from impermeable, high and hard walls which protect the occupants and inside which they are relatively self-sufficient, to that of a permeable membrane, a breathing organism which is integrally and vitally connected with its immediate environment. The museum with high walls experiences change as a breach, an unanticipated shock to a rigid system, an interruption to its focus. The museum as organism anticipates, prepares for and adapts to change because it is connected with the external environment.

This 'learning' paradigm, with its new possibilities and horizons, requires that museum professionals shift their perceptions of themselves and their organisations, and change their ways of working. This shift is encapsulated in the concept of the learning organisation described by Peter Senge.[3] For him, the learning organisation is characterised by the quality of holistic and advanced 'systemic' learning, rather than limited 'reactive' learning. The ability of organisations to survive and sustain themselves depends on the cultivation of this quality, more than on structures, targets and goals.

In Britain museums, with other public and private sector organisations, went through a 'culture' shift towards management and service in the 1980s. Crudely, this shift appeared in two forms. The first form emphasised customer service and care, and offered products, 'experiences' and services that customers valued. Typically, this was more pronounced in the private, commercial sector, and was accompanied by a greater stress on management and planning as agents of change. In the museum sector, independent museums were particularly strong leaders in the 'customer service' model, and in developing tighter practices in management, marketing and accountability. The second form emphasised social engagement and

1 David Anderson, *A Common Wealth: Museums and Learning in the United Kingdom* (London: HMSO) 1996.

2 David Anderson, 'Time, Dreams and Museology: We Are All Museologists Now', unpublished paper, 1997.

3 Peter Senge, *The Fifth Discipline: the Art and Practice of the Learning Organisation* (London: Century Business) 1993.

4 Local Government Board, *Getting Closer to the Public* (Local Government Board) 1987 and *Learning from the Public* (Local Government Board,) 1988.

participation, to involve the people for whom organisations provided services in their design and delivery; this was more common in the public and voluntary sector.[4] Typically, museums leading the field in the 'inclusive' model were part of local authorities in urban areas. Initiatives included Croydon Museum's consultative process for planning the new museum; Walsall Art Gallery and Museum's series of exhibitions, in which local collectors and their collections were featured under the banner of 'The People's Show'; and Sheffield Museums Service's outreach programmes.

Such changes were strongly endorsed by the National Audit Office's report, *The Road to Wigan Pier?*, which called for stronger focus and direction in museums, and stronger management and accountability. Since then, museum funding has been under great pressure in every part of the sector, and museums – with other service providers – are increasingly expected to at least respond to new political and social agendas without additional resources. At the same time, visitors have high expectations, and museums compete with many other leisure activities for their time and money. Thus the 'service culture' has become a matter of survival for museums; many have responded by promoting their mission of education and enjoyment, and by diversifying the public programmes and services they offer to the audiences they serve.

Museums that demonstrate their social relevance and value in terms that appeal to supporters and funders have gained further support for their work and vision. For example, Tyne and Wear Museums' access policy and programmes increased visitors and broadened their socio-economic range: the Discovery Museum attracted 300% more visitors in 1996 than in 1990, of whom 50% were first time visitors and 50% were from C2, D and E socio-economic groups. Because of their success, they were invited to draft the cultural strategy for the whole authority.[5] Walsall Museum and Art Gallery collaborated with local health authorities in 1996 on the exhibition 'Art, HIV and You' which boosted demand for HIV testing at a local clinic by 30%. The project has confirmed the value and raised the profile of the service's exhibitions and programmes.

However, many museum professionals have been slow to adopt and internalise the attributes of the new 'culture'. Some may resist it as undignified, diluting the museum's core values – a view supported by some visitors/customers, who are keen that museums should maintain their unique features and should not be caught up in the tide of the 'dumbing down' of culture into entertainment, 'experiences' and theme parks. Others may be instinctively cautious, sceptical of innovation and anxious to consider any new initiatives carefully before deciding whether to endorse and adopt them. They may be apprehensive and thus defensive, protecting themselves and limiting what they might offer to others. In a session on 'Working with Audiences', run by Mike Day, Sally Macdonald

5 David Fleming, 'The Regeneration Game', *Museums Journal*: No. 4, (London: Museums Association) 1997, pp. 32-33.

and myself at the Museums Association Conference in 1996, we asked participants to describe what was holding them back from consulting and working with their audiences in public programmes (if they were not already doing so). One reason cited was the belief that the public had limited expectations, and that the outcome of such consultation might be reductive rather than expansive. Yet the experience of museums such as the Museum of Science and Industry in Manchester has been that our visitors – and non-visitors – have huge, bold, extravagant and ambitious prospects.[6]

A crucial function of managers and leaders in seeking to promote integration is to address and seek to overcome fixed positions, resistance or reluctance by making a clear and genuine commitment to innovation, open consultation and participation, testing new approaches and supporting changes which facilitate and foster the 'service culture'. Organisations that embrace such commitments and embed them in day-to-day working practice, with a clear focus on their vision and their audiences and funders, are more flexible and responsive to change.

The formal roles to which people are allocated within their organisations may impede integrated and 'systemic' thinking. Many museums have reorganised formal roles into new organisational structures, but these continue to be represented in the linear 'tree' diagrams, dividing and separating departments, functions and individuals hierarchically. More relevant representations might be the interlocking cloverleaf of the Glenbow Museum in Calgary, Alberta, Canada,[7] the concentric circles and segments of the National Museum of Denmark in Copenhagen,[8] or even a 3-D model. The formal replacement of one neat organisational diagram with another usually conceals an informal process of displacement and transition, which is more messy, painful and slow. This transition is one which museums can usefully share and discuss. Fundamental changes at the Glenbow Museum were prompted by crisis: the published case study of this transition is honest, controversial and exceptional.

In the USA, the necessity for extensive organisational change is fully acknowledged and given a high profile by the professional body, the American Association of Museums (AAM). In 1995, it launched New Visions, an initiative 'to [help] institutions and individuals build their capacity for innovation and effectiveness'.[9] The initiative grew out of AAM's radical report of 1992, *Excellence and Equity: Education and the Public Dimension of Museums*. Responding to the increasingly diverse and multicultural profile of American society and the audiences under-represented in museums, the report addressed fundamental questions about their public role. It presented a plan of action centred on public service, education and inclusion, with 'dynamic, forceful leadership from individuals, institutions and organisations within and outside the museum community [as] the key to fulfilling museums' potential for public service'.[10]

6 Gaby Porter, 'Shaping Museums from the Outside In', papers from the CIMUSET conference, Manchester, September 1996.

7 Robert Janes, *Museums and the Paradox of Change: A Case Study in Urgent Adaptation* (Calgary: Glenbow Museum) 1995.

8 National Museum of Denmark, *Annual Report*, 1998.

9 American Association of Museums, *New Visions: Tools for Change in Museums* (Washington: American Association of Museums) 1995.

10 American Association of Museums, *Excellence and Equity: Education and the Public Dimension of Museums* (Washington: American Association of Museums) 1992, p. 4.

Working with museums to translate these principles into action, AAM felt that they were hindered by the lack of a framework and practical programme for change. They provided this with New Visions, which identified factors critical to an organisation's capacity to achieve and sustain change: mission, vision and leadership; planning; communication; inclusion; audience and professional development. They promote four guiding principles to create a climate for change: dialogue, as a way of communicating that encourages learning and is based on mutual respect; assessment, to consider the museum's current situation; vision to stimulate thinking about directions for change and providing an image of the future; and action, mobilising the museum towards change. This framework is close to the concepts and principles of Senge's learning organisation. His model has been used by museums in North America and, in 1996, by a group of museums in Canada under the banner of 'Learning Across Organisational Boundaries'.

In learning organisations, people work together to develop shared values and visions, and to share understanding and resolution of complex issues. The vision and values are active and current, providing a common purpose and point of reference, and a rationale for decisions. The vision needs to be sufficiently broad to deal with uncertainty, so that leaders or senior managers don't stick to hard planning when circumstances change, or feel guilty and disappointed when plans cannot be carried out.

Rather, a breadth of vision demonstrates that flexibility and direction are a powerful combination.

In Senge's learning organisation, the leader or manager's role is to give up tight control and move decisions down the hierarchy, enlisting others in seeking improvements and providing solutions. By devolving and distributing responsibility in this way, s/he encourages others to try their own ideas and to take responsibility for producing results. The leader's challenge is to let others make recommendations and decisions which may be different from what s/he might have recommended or decided (they may even be better, more appropriate or more creative). This delegation is especially vital in times of rapid change, because 'local actors' have current information and can move quickly to meet and adapt to changes.[11] It is resourceful because it empowers people working across the organisation and improves their decision-making abilities, so that they learn to combine thinking and acting. It also avoids the organisational inertia that requires everything to be referred upward and approved before being implemented: this inhibits learning and dampens people's enthusiasm.

The traditional orthodoxy of management is that the leader/manager has the answers. His or her reputation rests on being 'ahead of the game', knowing what's going on and having ready solutions. This new orthodoxy asks leaders and senior managers to honestly say that

11 David Bradford and Allen Cohen, *Power Up: Transforming Organizations through Shared Leadership* (New York: John Wiley and Sons) 1998.

they don't have all the answers, or even that there is no 'right answer'; to share their thinking and to show that they are open to having their thinking influenced by others. Their role is to create and facilitate strong and cohesive teams capable of addressing the important issues — collective, strategic or managerial — that individuals cannot address alone. The issues that museums face are complex and dynamic, constantly in flux and greater than one person or expertise. They need team and group effort, recognising that each discipline and section has a role and that decisions have an impact across a wide range of functions.[12] Good teams can share problems and build good solutions, with the best and most current knowledge of external and internal factors, and of their immediate and indirect impact. They mobilise people and foster commitment to shared goals, so that these become at least as important as each team member's individual goals. Team working may also encourage members to identify gaps in understanding and skills, and to look beyond the immediate work group or the organisation to plug these gaps.

In learning organisations, leaders and managers need to address issues and behaviours which hold people apart and inhibit their capacity to work together. In effective teams, everyone participates on an equal basis, so that one person or section doesn't dominate or assume relative superiority. An important function of the facilitator or leader is to deal with defensive behaviours — their own, and others' —

12 David Bradford and Allen Cohen, *Managing for Excellence: the Guide to Developing High Performance in Contemporary Organizations* (New York· John Wiley and Sons) 1984.

and to allow open discussion and disagreement. In this way, they encourage the team to work towards the best decisions as a group, not just the easiest. Creative tension generates energy and offers clues to critical areas of concern or transition. If expressed and managed constructively, conflict and disagreement may work towards achieving the vision.

In organisations committed to learning, transparency is crucial: leaders and senior managers undertake to clarify how and where decisions are made, and how others can influence them. This de-mystifies the decision-making process and shows how people reach good decisions; it avoids arbitrary allocations of responsibility, and 'hidden' or devious processes of allocating resources and making decisions. People outside and inside the organisation want to see who does what, when and where decisions are made, and who to communicate with to influence decisions. They quickly identify and respond to informal authority positions: for example, if the leader or manager proposes an idea which is adopted, but others' ideas are turned down without reasons given, this discourages people lower down or outside the organisation from making suggestions and offering feedback.

The most challenging aspect of transition is that you cannot contain and control change, deciding what and when to change, and when to stop: 'change' initiatives tend to spread and permeate everything. Organisations should anticipate and permit unsolicited feedback and

suggestions. For example, public meetings to consult with local black communities for Merseyside Maritime Museum's Transatlantic Slavery Gallery produced demands for a review of the museum's staffing structure and policy. People attending the meetings felt that if the National Museums and Galleries on Merseyside wanted to involve people from the local black communities, the organisation should recognise and validate their presence in this way. The museum was asked for a full-scale organisational audit in order to solicit opinions for a gallery which it saw as a discrete part of its operations.

Part of the role of leaders and managers is to assist 'organisational learning' by showing a willingness to cultivate ideas and take risks, and by demonstrating how they can be managed and spread. Thus others feel less constrained by the fear of failure, insecurity or retribution and more willing to experiment. Linked to this are the qualities of open enquiry, reflection and evaluation, and being prepared to give others' points of view equal validity with your own. These qualities encourage staff to be hungry and curious, taking a genuine interest in what others are saying and doing and how they can learn from them, using their skills and developing abilities in new areas. Organisations then become positive and generative, forward- and outward-looking.

Museums can truly become centres for personal learning with these approaches, so that the qualities they offer to their audiences are also nurtured and promoted among the people working in them: active, participatory and inclusive. Thus they create the possibility of a truly integrated experience, offering 'inreach' as well as outreach, spreading values in the core decisions of the organisation as well as public programmes and services.

ACKNOWLEDGEMENTS

I am grateful to the many people with whom I have talked and worked in museums, and particularly to the Museum of Science and Industry in Manchester, Effective Training and Development, the Museum Management Institute and the Museum Directors Group who have contributed to my management, and professional and personal development.

Chapter
Five

★

STORY
Curating with Young People

CASE STUDY
Working with Curators:
Comments from Young Tate
Display Group Members

ESSAY
Opening Up
the Curatorial Space

STORY

Curating with
Young People

Naomi Horlock

TESTING THE WATER:
A COLLECTION DISPLAY SELECTED BY YOUNG TATE

Introducing a group of non-specialists to the Tate's Modern Collection, with the aim of making a selection for a display, was a unique and challenging experience for the Gallery and the young people involved. Less than three months after the first Advisory Group was formed, members were asked to think about joining the group that would select a display. Fourteen young people opted to join, meeting at the Gallery every Wednesday evening for the next twelve months. Members of the Display Group, as it became known, needed to devote a lot of their free time to the project and maintain a high level of interest, and these factors were important in the self-selection of the participants.

As part of the research surrounding the Young Tate display, the Gallery was keen to learn from previous curating experiences that involved non-specialist groups selecting artworks for an exhibition. It became clear from discussions with professionals and participants from the BBC's Byker project and with Oldham Art Gallery's 'Back to Life' display, that the experience of selecting art had left participants, who had been mainly non-gallery visitors, with a more informed knowledge of the curating process. What emerged, however, was that a longer familiarisation or induction period was desirable, and the one-off nature of these experiences left participants feeling disappointed at their abrupt end.

The group worked with the Young Tate Co-ordinator and an Exhibitions Curator, Fiona Bradley. The aim of the project was to collaborate with Tate Gallery Liverpool in researching and curating a display of artworks selected from the Modern Collection and, through the display, to make the Tate's Collection of twentieth-century art more accessible to a young audience using the display.

A set of 'ground rules' or objectives were also put forward by the Gallery:

- the display should respond to the needs of a young audience, and the Group was to take advice, as well as advise Tate staff, in all relevant areas of work;
- in order to learn about curatorial practice at Tate Gallery Liverpool, the Group would look at how curators had put together displays in the past, as well as those currently on show;
- to help the young people understand the restrictions they would encounter in terms of conservation and the security of the building;
- that the display should look as professional as any other Gallery display, and that the experience of putting it together, as well as the end result, would be evaluated;
- to encourage debate around the cultural relationship between young people and museums, in response to criticism that institutions often fail to evaluate and disseminate their work;
- that the final responsibility for the display lay with the Exhibitions Curator.

The Display Group had an induction that introduced them to every aspect of curating a display. The Gallery and the young people learned a great deal from each other during this period. The Group members were conscious that they were becoming, in effect, 'young curators', making a display that would need to meet the high standards expected of any other Tate display. Through discussions with various members of staff they became familiar with how the Gallery

operates, learning about security, education, press and publicity, information, conservation, and the technical side of installing and looking after work once it arrives at the Gallery. The Group looked closely at the other Collection displays on show at the Gallery, discussing them with curators and information staff. They also met external specialists in the fields of interpretation and audience research.

THEMES AND SELECTION

It was decided that the most appropriate way for the Group to access the Collection was by feeding their ideas for a display theme to Fiona Bradley who had a good knowledge of the Collection. She could then research images which related to the themes, and advise on their availability.

Ideas for themes as diverse as anger, confusion, mind games, colours, depression, senses and emotion, mysteries, and 'feet' were put forward by the Group at the first few meetings. Several sets of images relating to a number of these categories were shown to the Group who, using actual Gallery displays, then applied workshop methods to develop ideas. Themes emerged with far more potential than those which had 'come off the top of their heads' – deception, reflection, troubled thoughts and suppressed emotions, journeys – providing the basis for a more focused look at the images selected by Fiona.

In spite of this approach, the Group went on to select works using their aesthetic instincts, at times losing sight of their chosen themes. By early December the group had short-listed approximately fifty paintings and sculptures – figurative, abstract and conceptual – which spanned the twentieth century. One particular work appealed to every member of the group: Richard Smith's large abstract painting *Riverfall* (1969), a startling piece made up of five curved and connected canvasses. It provoked a 'gut reaction', a totally aesthetic response which the Group found difficult to explain.

The Group visited the Collection Stores at the Tate London on three occasions to view the short-listed works. A major breakthrough

in defining the theme of the display had occurred by the second visit. Salvador Dalí's well-known painting, *Metamorphosis of Narcissus* (1937) had been short-listed, although the young people were reluctant to include it because of its poster icon status. Research by a member of the Group revealed that a poem written by Dalí to accompany the painting suggested several themes – adolescence, reflection, self-obsession, self-image – which the young people agreed could be used to link most of the works on the shortlist. In the poem, Dalí expanded upon the Greek myth of Narcissus, the youth who fell in love with his own reflection in a pool and was turned into a flower by the Gods.

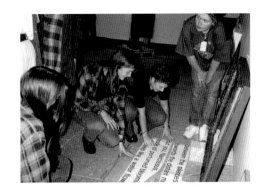

Firmly convinced that Dalí's poem was the handle on which to hang the display, the Group made their final choice of twenty-two works, abandoning those which failed to fit the broader themes suggested by the poem. This list of works was then taken to a Loans Board meeting at the Tate London, where the concept of the display was presented to senior staff. Agreement to the inclusion of all the works requested was given. There were conservation concerns over Richard Smith's *Riverfall*. However, the opportunity to exhibit the work for the first time in ten years, and for it to be seen outside London, swung the decision in the display's favour.

Examples of works the Group felt were appropriate to the themes in the poem included: adolescence – Bernard Perlin's *Orthodox Boys* (1948) and Gwen John's *Nude Girl* (1909-10); self-image – Ken Kiff's *Person Cutting an Image* (1965-71); reflection, both real and metaphorical – René Magritte's *Reckless Sleeper* (1928), Richard Smith's *Riverfall*, and William Turnbull's *Transparent Tubes* (1968). The journey from youth to maturity provided a further collective theme, as represented by Hans Bellmer's *Peg-Top* (c.1937-52) and Francis Bacon's *Study for a Portrait of Van Gogh IV* (1957).

Some works remained in the selection simply because they made direct connections with the poem. Kenneth Martin's *Oscillation* (1962), for example, was a contentious choice, agreed to

reluctantly because of a line in the poem which reads: 'under the split in the retreating black cloud / the invisible scale of spring is oscillating'. The work made a more logical point about the cycle of time as part of the journey through life after a member of the Group researched the definition of the word oscillation: the movement of a pendulum up and down or to and fro.

As the deadline for mailing the first press release in March 1995 approached, the need to make a decision about the title of the display became urgent. Possible titles were discussed at great length, focusing for some time on ideas taken from *The Wizard of Oz* or Lewis Carroll's *Through the Looking Glass*, which suggested journeys and altered states. The title needed to give a flavour of the display, and the choice was narrowed down to 'On Reflection' or 'Testing the Water'. The Group was keen to link metaphoric aspects of the Narcissus myth with the reflective nature of the works in the display. The Group voted for 'Testing the Water' unanimously, agreeing that the title was in keeping with the ethos of the project, that it reflected the experience both they and the Gallery were undergoing in selecting the display.

PUBLICATION

The content of the catalogue was discussed and it was decided that young people would write most of the text. This was to include entries on every work in 'Testing the Water', text on the theme and title of the display and the background to Young Tate.

The Group agreed that an Introduction, Preface and Acknowledgements page, written by Gallery staff should be included. Finally Paul Willis, author of *Moving Culture* (1991) and an informal adviser to Young Tate in the research and setting up period, was approached to write an essay, *Testing Curatorial Waters*.

The Group was anxious to produce a publication that was affordable for young people and that looked and read differently from the kind of catalogues usually produced by the Tate. Young Tate members later met with the graphic designer to discuss the style and format of the catalogue.

The young people used Tate acquisition catalogues, books on individual artists and movements, exhibition catalogues and information gathered from the Tate's library in London. Two of the group were able to interview the artist Mark Francis in his studio, and discuss his work *Source* (1992) – one of the works to be included in 'Testing the Water' – in more depth. The constraints of editing and print deadlines proved difficult for the Group: their texts needed to be ready by the end of May in order to have the catalogue ready for the private view at the end of September. Although this seemed reasonable to the Gallery, course work, impending exams, full- and part-time jobs, illness, apathy, crises of confidence or simply better things to do slowed the process down.

This period of writing and research emphasises the young people's dedication and staying power. The bulk of their research took place over the Easter holidays, six months into the project, and nearly six months before the display was scheduled to open. They worked in small groups with freelance writers when researching their entries for the catalogue, producing a draft and then re-writing it. This method resembled that of a tutorial, with one-to-one advice and guidance.

The Display Group met with a graphic designer to develop the brief for the catalogue, which is characterised by its large size (A3), electric blue cover and distinctive H_2O logo. The H_2O logo also identifies the display through button badges, posters and flyers, the latter having been distributed through clubs and venues around the North West.

INSTALLATION

Young Tate's role in the installation of the display had caused some concern for Gallery staff at the beginning of the project; the idea of fourteen young people being 'let loose' amongst unsecured artworks was an alarming prospect. As time passed and the installation of the show drew nearer, the Group became more familiar with the Gallery and its procedures, and in turn the Gallery became more familiar with the young people.

Ten of the fourteen young people in the Display Group spent time in the Gallery on the day the works were unpacked. They discussed the installation in great detail, offering their opinions on where the artworks should be positioned and giving reasons why. Some called in over the following days leading up to the opening and contributed more ideas towards the final look of the show.

PRIVATE VIEW

The private view was the culmination of twelve months of commitment and very hard work for the Display Group. This event was different from other Gallery openings due to the large number of young people who attended. There was very much a party atmosphere and, despite some Gallery concern, there were no incidents of young people 'misbehaving'. It was a busy, noisy and exciting event, which gave the young people the opportunity to entertain their families, friends and sponsors, and to show off the results of all those Wednesday night meetings and marathon trips to London.

A team of four young people had contributed their ideas and helped to plan the private view. An exclusive henna tattoo of the H_2O logo was available; a local band, Urban Strawberry Lunch – commissioned to make a soundtrack in response to the themes of 'Testing the Water' – performed in the Gallery on the opening night; there was also a pay bar, and a complimentary buffet.

EVALUATION

From the inception of the Young Tate Display Group, the meetings had been observed by a researcher from the University of Liverpool who later wrote a report. The meetings were all videoed.[1]

[1] See J. Hughes, *Ethnographic Study on Aspects of Young Tate, Liverpool*, unpublished report, the Institute of Irish Studies, University of Liverpool (1995)

In evaluating their curating experience, the Group recognised restrictions they had faced, such as availability of works, planning schedules, conservation considerations, deadlines for the commissioning and writing of catalogue texts, and so on, applied to Gallery curators too.

There was some criticism of the selection process in terms of the speed at which an initial shortlist of works had to be made, and the perceived vastness of the Collection compared to the Group's exposure to images through slides and reproductions. Again, the young people were aware of the reasons for this apparently limited view of the Collection, especially given the premise that in order to select from the Collection a knowledge of what you want to see is needed.

The research, writing and design of the catalogue also provoked mixed feelings within the Group. Some felt that the editing process had reduced the young people's voices too much, and the editing style seemed to echo 'the Tate's voice'. One young person commented that with so many different writing styles, the contributions read more as though they had been 'shaped' so they would read better. The editing of young people's writing was an issue for the Gallery. There was a clear dilemma of retaining the personality of the young people's work, whilst producing a publication which read in a cohesive and straightforward manner. Style, content and number of words varied from one contributor to the next, and despite the unorthodox presentation of the catalogue, there were constraints on the length of text.

Some of the young people have since criticised the catalogue for being too large to carry, and having too much text in small type. However, they acknowledged that the format was agreed by the Group and the considerable amount of text contributed to the 'crowded' look of the printed page.

The presence of Dalí's poem in the display, in the form of quotations around the walls and on the pillars, was also discussed. Although it was their idea to display the poem in this way, Young Tate members were divided in their opinions about its effectiveness in explaining the links between the works. Some felt the poem succeeded just by being in evidence on the walls, others felt it failed visually, whilst harsher critics in the Group felt the poem's presence was confusing, making the display more difficult to understand. Ironically, by linking their selection together thematically through Dalí's rather bizarre poem, the Group exposed the display to one criticism frequently levelled at modern art: that it is often inaccessible, obscure and as a result difficult to understand. Through the process of working with the Gallery, the Group became 'young curators', colonised by the curating process and the aesthetic of the beautiful hang. The Group recognised that they had lost sight of their original aim, that is, to make a display aimed at the Gallery's young audience. 'Testing the Water', they felt, appealed to all visitors, and they concluded that targeted displays were not needed.

The marketing of the display was criticised by the members of Young Tate. Despite good local and national press coverage, as well as some local radio and television exposure, the Group was disappointed by the lack of visible marketing in and around Liverpool. They were very happy with the 'club style' flyers produced for the display, which were popular and had become something of a collector's item. In discussing this issue it became apparent that it was not so much the 'restrained' marketing for 'Testing the Water' that was the problem, but what one Group member described as Tate Gallery Liverpool's 'invisible profile' in the city. The Group felt that the Gallery should promote itself more generically in the city centre, through poster sites at train stations and bus stops, and on billboards and buses.

CONCLUSION

Paul Willis assesses the Young Tate curating experience in his essay, *Testing Curatorial Waters*, where he puts forward the idea of 'naïve' curatorship as a means of predicting public taste:

> *There are many clues in this project for renewed practices to help arts professionals to make better or different kinds of cultural meanings for, and send out new kinds of messages to, existing and potential gallery users.*

The selection of Dalí's *Metamorphosis of Narcissus*, and the subsequent media and public attention, illustrate that a famous name and image attracts visitors over and above a display's theme or concept, and draws people in who may otherwise have passed by the Gallery's doors.

The success of the Gallery's cross-team approach to curating displays – the pairing-up of Exhibitions and Education curators in the development of a display – is mirrored in this collaboration with an outside group. The considerable commitment to sustaining the process on the part of the young people and the Gallery (eighteen months in all) demonstrates the seriousness with which the experience was viewed by all those involved. The involvement of non-specialists in the writing and designing of the 'Testing the Water' catalogue was a first for Gallery, and the private view was seen as a great success by both Young Tate and their guests.

The display's long-term impact on the culture of the Gallery is significant. 'Testing the Water' created a precedent for future Young Tate curating and interpretation projects. Though fewer resources were available, and the outcomes less newsworthy, projects such as 'Home and Away' labels, the Young Tate *Newsletter* and the Young Tate web-site are a natural legacy of the Display. These interventions into the institution by young people give an evolving and often experimental edge to the Gallery's curating philosophy.

Working with Curators:
Comments from Young Tate
Display Group Members

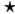

The following comments have been brought together to reflect the viewpoints of some young people involved in selecting 'Testing the Water'. All are contemporaneous responses except for those of Sarah James, who was asked to write about the experience two years on.

ON THE EXPERIENCE...

'Testing the Water' was more than just the title of a display – it was an expression of an experience, of grappling with the complexities of a great institution, a process of coming to terms with limitation and impossible aims; a pinnacle of the Display Group's efforts and energies, yet the foundation stone of the Young Tate.

Sarah James

Even though we began to know more about the Gallery, getting down to choosing work for the display was another matter. 'A collection display selected by Young Tate' – this sounds simple enough, but with no theme, no title, and no knowledge of what's in the Tate's Collection, choosing becomes a lot more difficult. For experienced

and trained curators, coming up with an idea for a show is fairly straightforward, but for fourteen untrained young people of different ages and backgrounds, with different interests and tastes, the process is a lot more complicated, but also a lot more exciting.

Looking back, the major difficulty with trying to select from the Tate's Collection for a display at the Tate in Liverpool, is that there is a vast quantity of work in it, and it's stored in London. You basically need to know what you want to see before you can request to see it. We looked at slide after slide, photo after photo (or often photocopy), and through catalogues with illustrations that were not much bigger than a postage stamp. In order to do this, we came up with ideas for themes, such as colour, reflection, deception, which Fiona then 'matched' with slides of work from the Tate in London. If all the work from the collection had been on CD ROM, our job would have been much easier (but would have taken far longer with more arguments).

Gary Clarke[1]

[1] G. Clarke and N. Horlock, 'In at the Deep End', unpublished paper for North West Arts Board conference 'Taking the Plunge: young people and art galleries' (1995).

[2] J. Hughes, *Ethnographic Study on Aspects of the Young Tate, Liverpool,* unpublished report, the Institute of Irish Studies, the University of Liverpool (1996).

[3] Exhibitions Curator, *Testing the Water,* Curatorial Evaluation paper (1996).

ON THE SELECTION OF WORKS…

We learned a lot of the stuff after we'd selected the works. We had to make the ultimate decision – which works were going to be included – right at the beginning, when we knew nothing about curating.

Gary Clarke[2]

The selection process took place at the very beginning of the project. This was necessary in order to get the request for works in to the Loans Board in time, but meant that we were asking the young people to select a display when they knew next to nothing about either the Collection, the Gallery or art as a whole.

Fiona Bradley[3]

ON THE THEME…

We seemed to select the pieces and build our theme around the pieces we'd chosen, instead of having the theme and picking the pieces.

Lee Reid[2]

The display was filled with themes of youth, adolescence, self-development, self-image and expression throughout the stages of one's life, themes that ran through our display and our Group. We defined the display further by linking our selection of modern art with a piece of literature – exploring the poem Dalí wrote alongside his *Metamorphosis of Narcissus*; re-interpreted, the poem linked to several of the selected works.

Sarah James

ON THE TITLE...

We all liked it because it linked the ideas in our display in a number of ways. One of these was that Young Tate had gone through new experiences. None of us had been involved in an exhibition or display before, so we were all 'testing the water'…The title *Testing the Water* is also connected to the theme of adolescence which runs through our display. Young people reaching adolescence are testing the waters of the adult world. Water reflects and distorts images, mirrors us and the world we inhabit. There are watery undercurrents to some of our choices; Narcissus is obsessed by his own reflection in the lake in Dalí's painting; Ithell Colquhoun reflects on her own body in *Scylla*, and Richard Smith's *Riverfall* draws us into its misty depths.

[4] *Testing the Water,* Tate Gallery Liverpool display catalogue (1995).

Sarah Jacobs[4]

ON RESEARCH AND WRITING ABOUT ART...

It was only when we began to research the works for the catalogue, in our groups of two or three that we started to learn about the artists, and really think about what the pieces meant to us, as well as to the show.

Kerry Bagan[1]

ON HOW THEY FELT BEFORE THE INSTALLATION WAS FINISHED, AND AFTER ALL WAS REVEALED...

Before I was disappointed...I thought they just hadn't listened to us whatsoever.
I thought it was terrible and I felt really sick and ashamed and embarrassed to have any
association with it. But now I see how the curators are so skilled at their job. Because they
obviously have foresight and everything looks really good. I'm really pleased.

Soraya Lemsatef[2]

(Before?) Well I think it was just that everything was on the floor and nothing was put
together. It's looking fabulous now. It really is. I'm dead pleased.

Michelle O'Dwyer[2]

...a lot of us don't think we've done anything different to what it usually is.
Someone in Education, he said that because we'd been working with it for so long,
it's not obvious to us that it's different. Although I'm not too sure! I don't think
we've broken any barriers, or made it interesting for young people.

Gary Clarke[2]

ON RIVERFALL...

Riverfall grabbed our attention from the moment we first saw it. Everyone felt passionately
about it, but found it difficult to say why...The colours glimmer off the surface of
the painting, giving a blurred effect, like being underwater. Riverfall gently draws you
in and sets you drifting through its reflective waters.

Paddy Brown[4]

...AND SEEING IT FOR THE FIRST TIME...

It's beautiful. More than I expected, more powerful. It's brighter, more domineering than I
thought it would be. It makes the room a bit warmer as well.

Lee Reid[1]

105

I love it. It's cheered me up a lot anyway. I thought it would be a lot darker, but its...mmm...better. It's sort of 3D. It just comes out at me. It's lovely. I think it sells the show. It's certainly cheered it up a lot more. It gives out a lot more colour.

Paddy Brown[2]

I think Riverfall is the sale of it. I think it just finishes it off. It's like the main piece of the exhibition. It's really good.

Michelle O'Dwyer[2]

AND ON THE INSTALLATION...

...for me, the installation was one of the most interesting days of the project. To be given the opportunity to see the works before they'd been hung, and to have a say on where they'd be hung was very exciting...it was no longer only words and photographs, it was the real thing, the display was taking on its physical shape.

Much of the afternoon was spent discussing the layout of the display. Some pieces remained in their original positions, but many were rearranged and moved. Many ideas came from the Group on how pieces should react and relate with one another, and eventually a plan for their positions was agreed.

For any display the final decision rests with the Gallery Curator, Lewis Biggs; ours was no different. Late that afternoon he was to see the display, and if he was unhappy with any aspect of it he could change it. A few of us met with Lewis at this time, and we wanted to change a few things round. He listened to our reasons for the choice of positioning and agreed with us.

Gary Clarke[1]

ON WHO WAS IT FOR?...

...I think we've lost sight of what we were actually supposed to be doing – putting an exhibition together to get young people into the Gallery. And what we've done

really is put an exhibition together for people who'd come into the Gallery normally.

Lee Reid[2]

ON REFLECTION...

I think, in the end, it shows that we've all grown up through it! I think I have.

Soraya Lemsatef[2]

I've gained a lot. I've been really lucky. It has been worth it. Being here on Monday, waiting for the doors to open when Riverfall arrived. I was beside myself. I was just so moved. I didn't think we'd come this far.

Kerrie Bagan[2]

In all honesty I believe we explored many objectives and created a successful display within the realistic boundaries, but, true to its title, we were doing nothing more than testing the waters of the slightly too insular curatorial world of the modern art institution.

Sarah James

Opening Up
the Curatorial Space

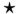

Lewis Biggs

One proposition behind the Young Tate initiative has been that the Gallery could increase its attractiveness to young people by explaining itself more adequately to this audience, or market segment. But explanations are of various kinds. The technological approach is one. Our enjoyment of music is increased by an understanding of how chords work; of driving by understanding how a car works; of voting by understanding how government works. In the range of explanations offered for works of art, some people are most keen to hear about the size of brush or colour tube of paint, about the 'f' stop and make of lens, about the chemical patina applied at the foundry and whether it stands up to frost. On the other hand, it has to be said that many people – particularly those to whom it has never occurred to try their hand at making a work of art – are left profoundly unsatisfied by these explanations. When it comes to computers, there are not many of us who try our hand at writing programmes, let alone making hardware, in order to increase our enjoyment of using one. Although my children (ages ten and eight) spend a lot of time at a computer screen, I am not sure it has ever occurred to them that a computer might require an 'explanation'. But if they did, I am unsure what kind of explanation would increase their enjoyment of using it: how does it work? how did it come to be there? why is it (the way it is)?

So far as Young Tate has been concerned, the question of 'how does it work?', applied to a curator of exhibitions, could be answered fairly simply for a particular group of young

people by getting the group to undertake all the various duties of the curator through the project of 'Testing the Water', about which more below. Lurking behind the wish to 'de-mystify' the role of the curator, the curatorial function as one strand of the museum's work, lies the desire to question why any particular museum takes the form it does. Before describing the process (how the curator works), then, I want to consider 'how the curator came to be there', on the way eventually to hoping to explain 'why the curator/the museum is the way it is'.

CURATORS AND EXPERTS

The title 'curator' was first used to mean manager or steward, and (according to the OED) especially someone who looked after young people. In the context of a museum it later came to mean someone who cares for a collection of objects. It is closely allied to the title 'curate' in the context of the Church (someone who cares for people or their souls) and 'keeper' in the context of zoos (someone who cares for animals). Some museums with collections of objects still employ 'keepers' although the title seems to be dying out, perhaps because of the increasingly embattled situation of zoos. In smaller museums and galleries, curators still tend to have the generalised function of taking care of things - not only the objects, but writing the labels, sweeping the floor, painting the walls, raising funds, giving guided tours, and everything else needed to care for the situation.

The growth of the leisure industry, and along with it the numbers and complexity of museums, in the last quarter of the century has produced a high degree of specialisation, within larger museums at least. Now there are not only cleaners who clean and warders to prevent the objects escaping, but conservation specialists, marketing specialists, teaching specialists, designers, technicians, and so on, all contributing to the work of the museum. In the larger museums, the role of the curator has become correspondingly narrower. Curators have had to choose between maintaining their 'catch-all' approach to collections of items and becoming managers, or becoming a specialist among other specialists. As specialists, they have concentrated on research of the sociological or historical context of objects (who made them, when, under what circumstances, for whom and for how much money, and so on). The curator defined in this way has been extremely rare, and probably has not really existed in this country outside the national museums, which were large enough to sustain staff dedicated to 'pure research' for a period between the fifties and the eighties.

It has been this research that has resulted in a museum display sometimes being arranged with the intention of interpreting a collection: for example, hanging paintings in a particular way in order to bring out the characteristics of a 'national school'. More often, collections have been hung in order to maximise the dramatic potential of a particular set of paintings within a

given space, and research considerations have taken second place to such things as scale, symmetry, frame style, colour scheme, and so on. This is not to demean the importance of research, but simply to recognise that the drama of aesthetics may be a better teacher than a didactic grammar.

Such research might seem to encompass a set of concerns for other experts rather than for a wide audience. But not if these concerns are brought to life, and bringing them to life is what a successful museum is able to do. As society has become increasingly reliant on the natural sciences to supply the burden of proof about all aspects of life, the traditional function of connoisseurship ('I know that is a Rembrandt from the benefit of my long experience and intuition') has been replaced by scientific proofs ('That is a painting by Rembrandt because radio carbon testing shows it was made in so and so, and the chemical composition of the paint is identical to that in *The Night Watch*'). If the physical properties of objects are more and more the special province of conservators, it is appropriate that curators should complement the conservator's field of knowledge by researching the metaphysical properties of objects. This is a key role, appropriate for a manager, because the reason any object is in a museum is because of some belief system, not because of a law of natural science. Museums are ultimately more about social beliefs than they are about the objects they contain. Museums are sometimes compared to temples, and their managers to priests.

DE-MYSTIFYING THE MUSEUM

The key elements in the museum belief system are: why the object is believed to be 'significant', for whom and in what circumstances. The fields of knowledge a curator must become familiar with are therefore: the range of objects from which any particular one is chosen, the concerns of the people who are going to experience it (the audience), and the conditions under which it is going to be experienced (the display context).

In introducing the members of Young Tate to the work of Tate Gallery Liverpool, all the different specialist functions of the staff were explored, but also it was necessary to show how the different tasks came together to create the final exhibition. In the culture of this particular Gallery, this function of exhibition management, of bringing it all together, of project management, is the responsibility of the Exhibitions Curators.

In de-mystifying the museum in the eyes of young people, then, the 'opening up of the curatorial space' has to be done in the context of unpacking the various functions of the museum. At Tate Gallery Liverpool there are no curators whose duties are limited to research: all curators are also 'executive' organisers. Education Curators research methods of engaging visitors and are also responsible for implementing visitor programmes; Exhibition Curators research artworks but are also responsible for organising exhibitions. The programme at Tate Gallery Liverpool is a sequence of exhibitions

interlinked with facilities and events for visitors (as individuals and as groups). Care of the visitor and care of the artwork are linked as closely as possible by requiring Education and Exhibition Curators to work as a 'pair' on each element of the programme. In the context of this Gallery, the 'curatorial space' means the 'theatre' in which the visitor and the artwork engage.

The theatre may be a more familiar analogy for the processes that go into the creation of programme in a gallery. The elements out of which a drama is made include the text, the actors, the props, the stage, the costumes, the lighting, the programme notes, the publicity, and of course the audience. Each element may be the responsibility of a different individual within the team, but there must be a vision of the drama to which everything contributes, and the vision is created by the artistic director out of his or her passion for, and knowledge of, the resources available. A good director produces something that presents the audience with a new and special experience of the text. A poor director often produces something in which the director's personality comes between the play and the audience, or where the different elements of the team fail to share a single vision.

Because artistic direction is at best a creative activity, it is also risky. The risks involve 'pushing' an audience to accept an interpretation that is new but that recreates the play in such a way that the integrity of the author's intentions is preserved. (It is of course a lazy convenience to assert that the intentions of the creator of a work of art are irrelevant or unknowable, that the subjective reading provides the only viable meaning. But for many playgoers and gallery visitors the question remains vital: they value an informed reading above an uninformed one.) At Tate Gallery Liverpool we try to engage our visitors in new ways while respecting the intention of the artists in the way the artworks are presented. The risk in the 'pairing' process between Education and Exhibition Curators that has been adopted at Tate Gallery Liverpool is that the vision grows organically between members of the team, rather than being imposed by a single artistic director, and may become insipid or insufficiently bold. However, since the artworks themselves are frequently challenging and always of extremely high quality, the sense of a stimulating vision producing a new experience is almost always apparent. Vision cannot be taught, but it can be acquired through experience or familiarity with a subject and with a process.

TESTING THE WATER TAKING THE PLUNGE

The 'curatorial space', the theatre of engagement between visitor and artwork, can be opened up but may turn out to be empty unless it is animated by a vision. Normally at Tate Gallery Liverpool the vision is supplied by the paired Education and Exhibition Curators, from their combined knowledge of the audience and the artworks. If this 'space' was to be de-mystified for the members of Young Tate,

how was this to be done? The vision had to be generated from within the knowledge and resources of the Young Tate team working on the project, in collaboration with the paired curators assigned to it. It seems to me that there were two crucial steps without which it is unlikely that any vision would have emerged. One was to accept that enjoyment and intuition are vital constituents of knowledge about artworks: passion is the key to vision. Second, the group was able to objectify its self-knowledge and generalise it into society at large. The Group 'took on' with the first step a relationship to the artworks, and with the second a relationship to the audience. The dramatic stage, or curatorial space, was set for the engagement of visitor and artwork.

Although research tools were made available to the Group, effectively the selection of artworks was made on the basis of intuition: the Group, as individuals, knew what it liked, and was encouraged to believe in its choices even if the degree of consensus on individual artworks was very low. The essential ingredient of the curator's vision is no different from that of any collector. We know that collections, whether of art or matchboxes, are the result of the act of choice, and that nothing is chosen unless the chooser believes the choice is worth a second look. The selection of artworks made by Young Tate was heterogeneous by any standard: diverse materials, the whole gamut of styles and degrees of representation or abstraction. This diversity within the selection created a powerful statement of the participants' belief in the ability of artworks to express or embody the range of their interests.

The second stage, the objectification or externalisation of their interests, emerged from the Group's interest in one particular painting – Salvador Dalí's *Metamorphosis of Narcissus* – as led by Fiona Bradley, who introduced the group to Dalí's painting and referred to the poem on the same subject. Through discussion of the painting and poem, the Group not only 'discovered' its narcissistic relationship to the art that it had selected (art that unsurprisingly mirrored and reflected its interests), but also learnt to appreciate the Freudian position that narcissism is a fundamental stage in psychological development, associated with young people in particular but therefore generalisable to the experience of anyone. The 'vision' of the curatorial space coalesced: the selected artworks would stand for aspects of the psyche, the river of life flowing around the room reflecting stages in the story of life from birth to death.

The visitor programmes run by Young Tate (called Taking the Plunge) became the method by which to propagate this vision by other means – drawing out the implication of the arrangement of the artworks in the room, the introductory panels and labels for individual artworks, the weaving of the text of Dalí's poem around the pillars and along the walls of the room, the catalogue and promotional flyers.

I believe it is greatly to the credit of the Group that they were prepared to rest their case

for making the exhibition entirely, and without pretension on their interests. The honesty and intellectual integrity of their 'narcissistic' position, as well as their enthusiasm for specific artworks, however 'disparate' and 'difficult' they might have been, shone through the exhibition. The approachability of 'Testing the Water' was also a challenge to curators to question their assumptions. Why do curators rack their brains to come up with new 'thematic' approaches to exhibitions in the apparent belief that 'issues' are needed to make art 'relevant' to gallery visitors? Is there an ulterior aim in this need to relate art to 'issues'? Many, perhaps most visitors evidently prefer to view an exhibition as a collection of artworks chosen for their own sake, like a personal collection, unrelated except through the self-justifying act of choice. To be sure, we would all like information so that we can deepen the quality of our discrimination, and we love to be introduced to the artwork by the person whose enthusiasm has singled it out for display…but how many of us go to art galleries to be faced with a 'relevant issue' embodied in an arrangement of artworks?

But of course the exhibition raised other questions for the institution also. The success of this part of the Gallery's programme, thanks to the input of Young Tate, doesn't make the job of the Gallery any easier. At Radio Merseyside's Young Tate Debate, which took place some months after the exhibition and was subsequently broadcast, the view was expressed by a number of young people that all the Gallery needed to do was more of the same. The Gallery certainly needs to do more that is similar, but creativity will not work to a formula. The way the Gallery engages with its young audiences will need to develop and move on, not forgetting the way that it relates to the many other audiences – older people, families, special needs groups, artists, art historians – and to other interest groups – local and national government, sponsors, the media industry and so on. Few members of these target audiences and interest groups are ready to acknowledge or tolerate the needs of other groups. In the film industry it is taken for granted that there are mutually exclusive markets and every film carries a censorship marking that is widely understood. The museum industry has yet to develop an equivalent clarity in its marketing, but even if it did so, it is not clear that tolerance and respect between different interest groups would emerge. National museums and galleries, like the BBC, are accountable to the democratic process by virtue of the subsidy they receive as much as, if not more than, to the sectional interests that support them. The nine o'clock deadline doesn't prevent angry television viewers objecting to the BBC showing 'adult' material upsetting to those viewers. Is the enforced 'consensus culture' of the national museums and galleries a reflection of successive governments' wishes to propagate consensus policies? How long can governments or cultural institutions resist the march of the plural market economy?

EVALUATION IN CONCLUSION

We need to conclude by asking what was learnt through the experience of organising 'Testing the Water' – by Young Tate, by the Gallery and by the visitors. Did the members of Young Tate learn anything about art? It seems certain that they did, not only information about particular artworks, but through the opportunity to spend time with artists and 'professionals' they were afforded the chance to become confident in their judgements, and to begin to appreciate the complexity of the subject if they wished to pursue it further. They also certainly learnt something about the Gallery. By visiting behind the scenes in the institution and spending time with different members of staff, they will have formed an impression of how such an organisation works, its values, and the atmosphere in which decisions are made. Great care was taken in inviting members of Young Tate to undertake the various functions of exhibition organisation, including marketing, print production, installation, labelling and signing, all of which will have given them a grasp of how the Gallery works. Perhaps most of all, like anyone in an unfamiliar situation, the members of Young Tate learnt something about themselves and their peers. And this of course remains one of the clearest and most valued reasons for visiting museums – by putting oneself among unfamiliar objects it is possible to constitute oneself and one's companions in a new way.

What did the Gallery learn? The chief lesson – an unsurprising one – seems to have been that young people are unlikely naturally to agree with each other about anything very much: take a dozen people (of any age) and you will get a dozen different views on art. Asking for a sense of direction, of vision or of decisiveness in relation to the unfamiliar territory of the Collection was therefore a redundant exercise. These things are likely to come only from familiarity with a subject. About less complex issues - the colour of the walls, the shape of the publication - it was easier to get original and clear decisions, because these things more nearly approximate to the familiar territory of everyday decisions.

What did visitors to the Gallery learn? This is perhaps the hardest question to answer and possibly the most important one. Did the Gallery attract more visitors of the target age of Young Tate during the exhibition? Did visitors of that age group find the display more accessible or exciting than other displays in the Gallery at the same time? No one has suggested that either of these propositions is true – no statistical data was collected, and no anecdotal evidence on these lines has been produced. The press coverage at the time was certainly appreciative of the Gallery's initiative in working directly with young people out of school, but this impression could have been formed among non-visitors as easily as among visitors. It was not related to the experience of the display itself.

POSTSCRIPT ON THE 'NON-CURATORIAL SPACE' FOR ART

How often is the 'curatorial space' 'opened up' to non-professionals? If the distinction between an exhibition and a collection is forgotten for a moment, there have certainly been more art exhibitions selected by non-professional curators than by professional ones. The press made much of John Major's decision to break with Mrs Thatcher's selection of art hanging in No. 10 Downing Street by installing his selection of twentieth-century art by British artists. Tony Blair has tried to demonstrate his concern for the nation's contemporary cultural creativity by replacing John Major's selection with his own selection of artworks by, for the main part, artists of his own generation. Every historic house and town hall contains a collection of paintings selected by a family or by a civic historical process, respectively, and carrying meanings – as a selection – at great remove from anything the artist or connoisseur of art might recognise.

But even in art galleries the appropriation of the curatorial space by the non-curator seems as much the rule as the exception. Every Royal Academy Summer Exhibition is selected not by a curator but by artists sitting in judgement on their peers; every John Moores Painting Competition is selected by a panel of artists and others which may or may not include a 'professional' curator. The Serpentine Gallery used to run a series of summer exhibitions selected by critics who may or may not have ever selected an exhibition before. The National Gallery has commissioned a celebrated series of exhibitions, called 'The Artist's Eye', selected by an artist from the collection, and in which the interest lies entirely in the biographical approach of the selector. In the late 1970s, the Whitechapel Art Gallery invited a number of artists to show a work of their own alongside a work of their choice by another artist.

Although not curators, critics and artists clearly have a knowledgeable interest in selecting an art exhibition (and possibly a more acute purpose in doing so than a professional curator). What about exhibitions selected by those who have no particular knowledge of or interest in art? The reply to this question must be: why would they choose art? The Art Gallery in Walsall and other galleries have pioneered the idea of the 'people's choice' exhibition in order to demonstrate that selection is something we all do all the time. Discriminating between the qualities of cultural artefacts is as natural as breathing. Enthusiasm for cultural artefacts is endemic. People choose to be curators of teapots, matchboxes, fire-irons…perhaps there never was a mystery about the 'curatorial space', just the recognition that curators spend more of their time with their chosen subject and can talk about their 'vision' with understanding and passion.

Chapter Six

★

STORY

Taking on More

Naomi Horlock

DEVELOPING A CLEARER APPROACH
TO PROGRAMMING AND PEER-LED WORK

Young Tate's third year (1996-97) was one of consolidation and experimentation. The move away from the 'closed' nature of the Advisory Group in its second year allowed the Gallery to create a wider forum for young people's views and ideas. New approaches to programming and education methodology were trialled, and the voice of Young Tate was expressed using a variety of media.

It became clear within the first few months of Young Tate's third year that attendance at the monthly Advisory Group meetings was beginning to fall. Meetings were becoming less and less sustainable, and as a direct result increasingly ineffective. The same small group of regulars attended, but even their numbers were decreasing. The methods of consultation between young people and the Gallery required updating and widening to include a broader cross-section of opinions.

A decision was taken to suspend Advisory Group meetings because the Group no longer felt it had a role. In its place smaller focused project groups were established. Young Tate's advisory role would not be lost, but re-defined; several of the founder members of the Group remained involved. Project groups with a clear focus were to bring about a richer, more informed working relationship between the Gallery and young people, giving Young Tate members – particularly newcomers – an opportunity to become more involved in Young Tate beyond workshop activities.

PEER-LED WORK

We understand peer education to be education and training provided by people who are in some sense the peers of learners…Our belief is that within peer education young people should have a significant say in the design and planning of education and training, as well as being able to participate in the management of a project.[1]

During Young Tate's first two years, young people were on the periphery of the workshop planning process: their role resembled that of a helper within the team rather than an active participant. The selection of young people for the role of paid workshop leader was based on a combination of factors:

- the individual's experience of participating in a workshop as well as helping to lead one;
- their confidence in putting forward ideas or commenting on aspects of the planning process;
- their relationship with the Young Tate Co-ordinator;
- their knowledge of the display or exhibition, and understanding of the issues raised by the artworks;

In order to establish a sound basis for working in this way, the Gallery began to extend its knowledge of peer education policy within the context of the Liverpool City Youth Service. Precedents for peer-led work with young people through the Youth Service are plentiful, particularly in the fields of health and drugs awareness. Drama-based work lends itself well to the promotion of peer-led involvement, but there is less evidence of peer-led work with young people in the visual arts, and very little of a long-term, sustainable nature with museums and galleries.[2]

The young people's preparation for their role as workshop or drop-in leaders became more structured. They were taken through a series of ideas and strategies prepared in advance by the participating artist and the Young Tate Co-ordinator. Following an introduction to the display or exhibition, the Young Tate team was invited to comment on the workshop plan and to suggest changes or alternative approaches. They were then assigned two or three tasks to introduce and lead. They also assisted with other aspects of the workshop/drop-in, and had the additional responsibility of running evaluation sessions with participants at the end of the day's activity.

This method of preparation was particularly effective when the same team of leaders ran a workshop around a display on more than one occasion. However, young people's involvement in the planning process was limited, and its directive nature often failed to fully optimise their

[1] British Youth Council leaflet, *Introduction to Peer-led Education Methods.*

[2] Interesting exceptions include the Stickies (Cleveland Youth Arts), a youth group who developed a relationship with Cleveland Art Gallery circa 1993; also the Hermitage Gallery in Brentwood, a space for young artists under the age of 25. It is managed and curated by Brentwood Youth Arts Forum and the Brentwood Youth Arts Partnership.

potential or to develop their planning skills. Even the more experienced Young Tate leader might have felt unclear of their role or compromised in their position as a facilitator to their peers. One twenty-three year old commented that she felt she might be patronising some of the workshop participants who she knew had been involved with Young Tate from the start. Another, aged fifteen, described the difficulty of leading a session for the first time, aware that she was younger than many of the participants.

Peer education within Young Tate grew out of a partnership with young people, evolving from their willingness to assist with workshops in the early days of the programme. As Young Tate developed, young people's involvement in advising and assisting with programming increased. The introduction of a peer-led approach to working with young audiences was not a deliberate strategy; it developed over time, growing out of the experience gained from the Gallery's close working relationship with the Advisory and Display Groups. The adoption of peer-led practice by the Gallery was almost instinctive, the result of adapting to young people's regular presence in the building and responding to their energy, enthusiasm, and most importantly, their ideas. The development of a consistent and more professionalised approach to peer-led work will be discussed further later in this chapter and in Chapter 7.

YOUNG TATE PROGRAMME

Bookings for Young Tate workshops were low, and the young people felt this was partly due to the 'intimidating factors' associated with booking a place: telephoning the Gallery was seen as one of the most off-putting aspects for a young person unfamiliar with Tate Gallery Liverpool. The workshops also required an individual to make a commitment for the whole day, often with little knowledge or experience of the Gallery or of what a workshop might entail. The Gallery decided to trial drop-in events, as a direct result of feedback from Young Tate workshop leaders and participants. Their appeal was twofold: for young weekend visitors

the 'no commitment to stay' nature, providing an opportunity to 'sample' the programme, and for the Gallery the potential for further audience development. There was a great deal of confidence that drop-ins would attract older teenagers, who Young Tate members felt were more interested in discussion and research.

Free afternoon drop-ins were introduced in June 1996, in place of monthly Sunday workshops, in an attempt to address a range of interests by offering a 'shop-window' of activities for young people of all ages. The drop-in team was based in the studio where Young Tate workshop leaders were on hand to meet young people, tell them about the session and the display or exhibition it focused on, and to introduce a gallery-based task if they were interested in finding out more. A new Young Tate leaflet aimed at publicising the programme was launched as part of a Gallery-wide marketing strategy. The first drop-ins were well attended, attracting up to thirty young people to each session, with exhibitions proving more popular than displays.

The first drop-ins attempted to give a sense of continuity by looking at an exhibition over two Sunday afternoons; for example, we focused on 'Rachel Whiteread: Shedding Life' in the October and November sessions. This was to allow the Young Tate team to work on the same drop-in on more than one occasion, enabling participants to return the following month to extend their ideas further. Evidence of young people's responses to a display or exhibition in the form of written and practical work was displayed to give young visitors an idea of the kind of work produced at previous sessions.

Activities ranged from gallery-based tasks and some practical work to video screenings, and there was an area for reading catalogues and books related to the show. One drop-in – centred on the display 'Wandering About in the Future: New Tate Acquisitions', and led by artist Alan Dunn and two Young Tate facilitators – asked young people to take a question or statement which referred to an issue raised by the work. The subjects covered included sexuality, age, artist as celebrity, art and money, death, physicality, and who looks at whom.

The idea behind this approach was to encourage young people to discuss contemporary art and its interpretation, responding to the information the question gave by producing a letter to the artist or an extended label for the work. The level of debate and the quality of the responses was encouraging, with participants going on to develop practical work using an empty audio cassette box as a 'container' for their ideas.

EVALUATION

Although the first few summer drop-ins were well attended, interest had begun to wane by the autumn. A decision was taken to suspend drop-ins and return to workshops. Several factors contributed to the overall lack of success of the drop-in initiative. There was an absence of young visitors to the Gallery on Sunday afternoons when the sessions took place. A seasonal factor appears to have affected attendance; a drop-in leaflet was introduced in October, but interest waned as the winter months took hold. The type of display or exhibition upon which the drop-in was centred also played a part: numbers were significantly higher for temporary exhibitions, Collection displays proving less popular, suggesting young people preferred the more contemporary work of artists such as Rachel Whiteread.

It emerged that the younger age range was attracted by the more practical elements of the drop-in, spending more time with the activities if visiting in their own time and with prior knowledge of the event. Feedback from older Young Tate members (aged sixteen and over), some of whom were studying art at A-level or above, reported that their age group wanted more discussion, debate and study. Practical activities, viewed by an eighteen-year-old 'dropping-in', were off-putting, especially as these were more attractive to under-sixteens. In trying to provide something for everyone we found that drop-ins were actually discouraging some young people from taking part. It was felt that drop-in visitors were generally unwilling to commit a great deal of time to the event, preferring to go about their visit independently. The absence of

commitment, at first seen as a major attraction of the drop-ins, proved to be a major flaw in their effectiveness.

MIRÓ THREE-DAY SUMMER PROJECT

The exhibition 'Joan Miró: Printmaking from Figuration to Gesture' was the focus of this project, and attracted a great deal of interest from young people. The project introduced Miró's ideas and printmaking processes by examining the development of his visual language from the 1930s to the 1960s. Working with an artist, a printmaker, two Young Tate members and Gallery staff, thirty young people explored Miró's work through gallery-based tasks, talks, video screenings, demonstrations and practical printmaking in the studio.

Young people referred to the exhibition throughout the project, building up their knowledge and understanding of the artist's ideas and practice. Miró's visual language can be seen as 'shorthand', recognisable as a character or symbol to those who are familiar with his style. The young people developed ideas for their own personal 'language', creating symbols or characters whose meaning was known only to themselves.

Feedback from participants of this project was usefully critical as well as complimentary. The young people involved said they had experienced a very satisfying range of activities from which they had gained a good understanding of Miró's work. They had particularly enjoyed the practical printmaking, producing a large selection of prints individually and as a group, and understood the relationship between the exhibition and the work they had made in response to it. However, one criticism was the lack of a more formal talk or lecture, something young people said they expected and would have liked, as well as the more informal talks and discussions.

INTERPRETATION PROJECT – 'HOME AND AWAY' LABELS

Seven Young Tate members, all aged between fifteen and twenty-one, were invited to take part in an interpretation project centred on the display 'Home and Away: Internationalism and British Art 1900-1996'. The aim of the project was for the group to research a selection of works in the display, and write a 'Young Tate' label text for each of them. All of the works in the display had a label which had been written by the Gallery; the Young Tate labels placed next to the work would complement the existing labels and offer second interpretive 'voice' about the works.

The Group worked one evening per week for eight weeks over the summer with Exhibitions Curator, Katrina Brown and the Young Tate Co-ordinator. They discussed a label's function and content: should it contain purely factual information such as biography and art

history, more interpretive detail which offers insights into the work's meaning, or does an artwork need a label to 'explain' it at all? All the participants agreed that artworks should have an accompanying label but felt that the language used by curators, and the art history they referred to when contextualising a work, was often off-putting to younger and older visitors alike.

The length of the label text was set at one hundred words. This figure reflected two constraints: the first being the amount of text the gallery visitor is likely to want to read in a display; the second, on a practical level, the size of the label holders used by the Gallery.

The selection of works to 'label' began with a workshop in the display. Working in pairs, Group members were asked to choose two artworks: one they felt was interesting or accessible, and one they found difficult to understand. Then, in front of those works, they jotted down responses and discussed the ideas and issues they felt the pieces raised. They were encouraged to develop these initial responses, and to think about ways of making their label more personal or evocative by referring to other sources such as quotes by the artist, literature, poetry and popular culture.

The information used to research works came from two main sources: the existing label, and a three to four page 'dossier' written on each artist in the display and available to all visitors from the information room within the display. Supplementary information such as catalogues, art history books and art videos was also made available to the young people.

The main difficulties encountered by most of the Group in writing their labels was a tendency to echo information and ideas already covered in the existing labels or the artists' dossiers. First drafts served to demonstrate their knowledge, but on the whole failed to say anything new. The young people were therefore encouraged to return to the initial responses they had experienced in the workshop, and to the ideas thrown up during group discussion. The resulting texts were fresh and accessible, highlighting the potential this approach offers to interpretive labelling. Response to the Young Tate labels was generally very positive. Comments from visitors and staff indicated they enjoyed these 'alternative' voices.

One outcome of the project was to provide a straightforward and practical solution to an enduring Gallery problem. Labels relating to a sculpture are often difficult to locate in a gallery as they are usually placed on a wall and are not easily noticeable. The Group suggested incorporating a silhouette of each sculpture onto its corresponding label, over which the text was placed.[3]

3 Having created a precedent, individual Gallery visitors from a wide age range have since written labels to accompany works in the Landscape section of 'Modern British Art'.

She was dressed in rich materials satins and lace and silks all of white… I saw that everything within my view, which ought to be white, had been white long ago, and had lost its lustre, and was faded and yellow… Not even the layered bridal dress on the collapsed form could have looked so like grave clothes, or the long veil so like a shroud.

extract from *Great Expectations* Charles Dickens where Pip first meets Miss Haversham

Walking down the gallery was like walking down the aisle. There was a halo or crown around the creature's head, which I realised was formed by four teats the female life-giving source. The halo made the creature seem more daunting. It dominated the gallery: was I supposed to bow? Or shower it with gifts? Was it some god or goddess, or a shrine to worship at?

Young Tate label created by Catherine Smith
for *Virgin Shroud* (1993) Dorothy Cross

CONCLUSION

Young Tate's third year saw the programme mature and take stock of the effectiveness of its services to young people. Young Tate's membership had successfully been opened up, resulting in a steady increase in numbers and, consequently, a wider range of young people taking part in curating projects and helping to lead workshops. The introduction of drop-ins in place of workshops was a useful experiment, the difficulties encountered providing a strong stimulus for re-defining Young Tate's future programme.

Radio Merseyside's Young Tate Debate (excerpts in the case study below) is one example of an event largely controlled and facilitated by young people. However, the quality of peer-led work was in need of review and re-assessment. During year three it became apparent that young people's contribution to the planning process was increasingly becoming more defined by the adult facilitators. The workshop planning process often lacked the necessary measures of involvement which help to define peer-led work, such as taking the initiative in contributing to planning and ideas, and taking on more responsibility as a peer educator. These shortcomings were exacerbated by the problem of familiarising a team of young people with an exhibition to the degree that they could then feel confident enough to develop a workshop plan with an artist.

The most logical and empowering solution to this dilemma was thought to be the introduction of a clear training route for Young Tate workshop leaders. Peer educator training is at the core of good youth work practice. Young Tate's ethos was now firmly centred on the continued development of peer-led work, and in professionalising the Gallery's approach to training and raising the quality of young people's experience.

Fiona: Neither did I but unfortunately we had to hand the
building over to the contractors!

Have you got any other works lined up for when that one goes off?

Lewis: We're planning the displays from the Collection and the temporary exhibitions –
the loan exhibitions – two or three years in advance. The loan exhibitions have to be
planned that far in advance because the works belong to different people and
collections, and by the time you have written to them all and you've got permission to
borrow them or they've written back and said no, try somewhere else…it takes a very
long time. That planning ahead is an in-built part of the process. It would be very nice
sometimes to react much more quickly but we simply couldn't get hold of the art.

*If a lot of people were very much interested in seeing a particular artist or exhibition,
would the Tate Gallery be able to get it?*

Lewis: We'd try! The exhibition we're asked to display most often is the Magritte
exhibition or a Salvador Dalí exhibition. Because Fiona is an expert on Salvador Dalí's
work, we have an asset that we can trade with other museums, to try to get them to
loan us Dalí paintings. Fortunately exhibitions like a Dalí exhibition are big business;
they make a certain amount of money – though you have to put money into these
exhibitions. Having a lot of people through a museum is very good for a museum.

*Regardless of who you're exhibiting, Dalí or whatever, do you feel that if a person
was to come into the museum they might be alienated from the initial thought behind
whatever work, seeing as though you're coming into a blank white space?*

Lee: Unfortunately people do have misconceptions about galleries and think that they
are very elitist – that only the *crème de la crème* can appreciate art. It isn't true at all. I
think one thing the Tate can do to improve that is when you walk into an exhibition,
have as much information about the work that is on show as possible. So as soon as
people walk in they are told the themes of the exhibition they are going to be looking
at and the background to the work. The Tate Gallery, and other galleries as well, do
need to open up and provide as much information as possible for the people who will
be coming in who haven't got the background information.

Would you actually advertise the exhibitions?

Sarah: I have a problem with the way the Tate advertises. Maybe it's more a problem with the way art isn't seen as popular culture. We can get music, cinema, film advertising everywhere but there's something missing with art. I found a Rachel Whiteread poster in my train station the other day, which was quite a big achievement!

Fiona: There's also the money issue. I'm very pleased you've noticed the Rachel Whiteread posters in the station, because it is a big campaign at the moment. We have to make choices all the time; do we do a poster, do we do something else with the small amount of money that we've got?

Lewis: With a play or a concert or anything else where you take money at the door, the more money you put into advertising, the more money you make back on the door. We hardly take any money on the door, so money we put into advertising we don't necessarily get back again.

You mention that the Tate doesn't own very much video art and installation art; why is this? That's the way that art is going at the moment.

Lewis: Because video art started in 1968 and the Tate's Modern Collection goes back to the year 1900, so it's been able to collect video art for a very short period, compared with the time it has had to collect paintings and sculptures. It is now collecting but it takes a long time to build up the reserves that it has in the other media.

Luke: I'd like to ask those on the panel who were involved in the 'Testing the Water' project what they thought of the project as a whole. Would they do it again, and if they would do it again, what would they do differently?

Lee: We loved doing it, just to find out what goes into curating an exhibition. It isn't just a matter of looking at a load of paintings and sculptures and saying they'll do, in they go. It took us twelve months but yeah, we would do it again. In terms of doing it differently, I think we'd spend a lot less time arguing about what theme to choose, and a lot more time looking into the works that we were going to put into the exhibition.

Sarah: Can I just say one thing about it? I don't mean to be critical of it at all, but

unfortunately the problem with setting up such a group as the Young Tate, the fourteen of us that curated it, is that it made us totally elitist. I don't want to say I'm completely Tatified, but we've been taken in and we've learned.

The 'Testing the Water' project sounds very interesting.
Are there any plans to hold a future project?

Lewis: Not right now. We've heard a lot about the exhibition but the Young Tate do a variety of things and that is part of the Gallery's relationship with Young Tate – to learn more about what young people want. We haven't learnt everything about exhibitions, obviously, but there are also workshops and a variety of activities, and we're trying to learn from all those different areas. Any of the activities can come up for renewal.

Do you tend to streamline your exhibitions to well-known artists or why don't you
display local artists, as that might establish people more?

Fiona: There are two answers to that. The first one is we have. 'Making It' was an exhibition last summer and featured the work of younger artists working in the region. We're here to show the National Collection, and we're here to supplement the National Collection with exhibitions of work by artists which we think complements the Collection and perhaps should be acquired for the National Collection. We're an international gallery so we have lots of different constituencies.

Can I ask Lewis and Fiona how the Tate is funded and what they do with the
money, and would you be interested in sponsoring individual performers or any
other art-related subject?

Lewis: Where do we get the money from? A lot of the money comes from the government and the Department of National Heritage. That covers our running costs. We also need to raise sponsorship and donations and admission charges and fees – enough money to run the programme. That means we have to put on exhibitions that people want to sponsor, so there is a commercial side to find enough funds to keep the Gallery going.

What do we spend it on? Well, this building is very expensive to run, unfortunately. One reason is that the National Collection has to be kept under secure conditions, which are air-conditioned. A lot of money goes on staffing. We too feel it is absolutely essential to have people in the galleries talking beside the area. A lot of money goes towards producing the programme.

Your question was concerning whether we can commission artists to do particular projects. Our prime responsibility is to visual artists. Also, as part of our interpretative activity, we work with poets and actors and other kinds of artists, dancers. It's not our place to go out and commission dance for the sake of it. The dance or poetry or whatever has to be about the visual art that we're showing.

How important are young people to the Tate?

Fiona: I think I'd say that the Gallery values young people as much as it values the rest of its audience. We are interested in young people, there is the kind of 'get them young and you've got them for the rest of their lives' approach. Also, I wonder whether young people have the prerogative in terms of being nervous about the Gallery. I'm terrified to go into clubs – but young people seem to manage it! We value the energy of young people very, very highly, and the ideas of young people. 'Testing the Water' was a fantastic project which has fed into the way that we work.

Will it always be free to enter the Tate?

Lewis: I don't know is the honest answer. At the moment the Tate Trustees are dead set on keeping it free. I don't know how long it is going to be possible for the other national collections to allow the people to see their own art for free. It's a complex question, and depends perhaps on the next government.

Sarah: I think a lot of Gallery staff are very aware that people, especially young people, find it a bit disconcerting that they have to pay to get in – and also misunderstand as well that most of the Gallery is free, that it's only temporary exhibitions that you have to pay for. But if you go down to London, or if you travel on the continent, exhibitions are much more expensive and perhaps that's why they are

able to get these great names or really exciting work, and I think we do show a lot of really exciting work and a lot of the time it's young people particularly who find it exciting. With 'Wandering About in the Future', many young people tell me that the work in that show was far more interesting to them than 'Characters and Conversations' because it was about now, and it was about cutting-edge art, as they saw it.

More young people have access to the Internet now. If the Tate continues to charge entry to exhibitions, young people may be forced to seek alternative methods to view art or find out information about art. Do you feel threatened by the Internet?

Fiona: There's a lot of debate around at the moment about whether the Gallery should use the Internet as an information service, whether we should, if you like, advertise on the Internet – have a home page which tells people what they can see – or whether we should be doing artists' projects on the Internet so that people could access those projects at home. I don't know enough about the Internet, I don't know artists who work in that way, but I am committed to putting the Gallery onto the Internet. All the people who work here are obsessed with objects and what we want is for people to dial us up on the Internet, look at what we've got and then come in and see the objects, rather than just staying at home in their bedrooms with their screens. So I don't think that we feel threatened. I hope that we see it as an opportunity.

How is the Young Tate funded?

Lee: There is a budget set aside by the Tate – not a very big one – which covers our expenses.

Gillian Miller (Development Manager, Tate Gallery Liverpool) in audience: 'Testing the Water' was actually sponsored by Ian Short Partnership, who are a local law firm. We had some money this year for the continuation of Young Tate from the Gulbenkian Foundation.

When I asked my friends what they thought about the Tate Gallery, a lot of them had never heard of it or thought it was boring. Is there any way you could make it more appealing to the public?

Lee: It's not just the Tate Gallery that needs to have its image improved, it's the whole attitude people have towards the arts, not just in Merseyside. If you're not in the arts community, then you don't seem to find out about what's going on, and therefore people have the attitude towards it of 'oh, it's not for me, it's all snooty'.
The way to do it is through publicity and advertising. It does need to be portrayed as somewhere you can go and actually enjoy yourself.

Lewis: I think we need to get the elitism thing into perspective. We have 600,000 visits a year and the population of Liverpool is 450,000. I don't say we're complacent, it would be nicer if a million and a half people came every year, but 600,000 is a huge number of people. It's a lot more than Liverpool Museum. Ninety per cent of our visits are made by north west regional people. Ten per cent of our visits are made by people who live outside the North West.

Sarah: Everybody has been saying how important are we to the Tate, but how important is the Tate to you? How much do you want to come, how much do you want to see art here?

Is modern art important? Does everyone on the panel appreciate a blue painted piece of canvas? Do you really appreciate it; is it art?

Sarah: What do you perceive art to be?

I'm going back to A-level now, but if you entered any of the stuff that you've got up there for A-level, or maybe some of it would get it, but it would just be, like, a piece of canvas painted blue and orange is a piece of canvas painted blue and orange.

Lee: You do really need to know what is behind it, why the artist has done it because, yeah, if you just look at it…I mean, some things are just done because they look nice. You know, like Riverfall which was in the 'Testing the Water' display – it was a massive piece which covered an entire back wall and it was just shades of green and bluey greens and all that. It was just nice to look at, it didn't mean anything, it didn't have any deep-rooted meaning or anything. You know, you could just sit there and look at it and it had nice colours, a really nice use of colour. It wasn't meant to be anything more. So from that point of view, yeah I do appreciate modern art.

Why does the Tate in Liverpool show modern art and
not art from across the spectrum?

Lewis: Because of the Walker Art Gallery and the Lady Lever Art Gallery and the Sudley
Art Gallery, and all the other magnificent collections of pre-twentieth-century art which
there are in Merseyside already. When it was decided to convert this building and put
the Tate Collection in it, the obvious thing to do was to put twentieth-century art in it
to, if you like, finish off where the Walker Gallery had left off.

With regard to the Tate's corporate identity, why does the Tate use large, well-known
design agencies when there are many young graphic designers who could produce
fantastic graphics at a fraction of the price?

Lewis: We do use a local designer to produce our design on a week-in, week-out basis.
The house style was set up by Pentagram corporately, for the Tate as a whole in
St Ives, London and Liverpool.

The Tate Liverpool seems to be living in London's shadow. Does the Tate in Liverpool
have plans to hold exhibitions such as Damien Hirst or any other major artists which
would attract mass media and national attention?

Fiona: Rachel Whiteread is what I would say to that! We really hoped that showing
Rachel Whiteread would do all that for us, and I think we've been proved right.
We've had enormous media attention for the Rachel Whiteread show.
We've had very good attendance figures and we're very proud of it.
So that would be the answer to that question.

How is the artist in residence chosen, and who is it at the moment?

Fiona: The artist in residence programme is sponsored by Momart, the art-handling
company, and it's chosen by open submission. We advertise every year, in the *Artists'*
Newsletter, and *The Guardian*, and in colleges and in as many places as we can
humanly advertise. And we invite artists to submit slides and a proposal for what they
would like to do up here. We offer a six-month residency with a bursary and a studio.

There are no demands made on the artist, we just ask that they move here,
if they don't already live in Liverpool, and make work in the Gallery.
This year we've had Emma Rushton.

*I didn't know the first thing about art or art as a culture or pictures because I'm more
into the performing arts side. The Tate helped me to understand the fact that it is not
just a piece of canvas on a wall, and it's not just pencil on paper; there's something
behind it, and as a member of Young Tate I think that's really important.
And the fact that the gallery is portrayed as dull – one of the reasons Young Tate was
formed was to try and change that. I think that's because young people these days
are typecast as thugs or idiots sometimes.*

Learning in Art Museums:
Strategies of Interpretation

Eilean Hooper-Greenhill

THE PROCESSES OF INTERPRETATION

What happens when we encounter a painting and want to try to understand it? What is the process of trying to make meaning? In order to unpick this process, I want to draw on two areas of study: firstly that involved in teaching in an art museum, and in working with many different groups of visitors to explore art objects, and secondly, the insights offered through some aspects of hermeneutics. In teaching at the National Portrait Gallery in London, I frequently found myself working with groups with the portrait of Elizabeth I known as the Ditchley Portrait (see Plate 1). Using this as an example, I want first to consider the process of exploring the painting, and then secondly, to reflect on how some of Gadamer's ideas, which are drawn from the philosophical approach known as hermeneutics (which,

broadly speaking, means 'interpretation'), explain this process.

A first glance at the Ditchley painting presents an overall impression of a woman wearing a white dress who looks as though she lived in the past. As human beings, we tend at a basic level of species recognition to be attracted to faces, and it is the face that we focus on next. This is followed by a scan of the image as a whole, looking at both the figure and the background.

At this stage, we try to recognise some aspect of the painting in more detail, to try to make a connection with something that we already know and feel confident about. This might relate to any aspect of the work. It might include elements of the image in the painting, such as the woman herself, the historical style or

period, or parts of the background of the painting. Or it might be that we recognise this kind of image as a general class of objects (portraits).

We try to find something that we can either recognise or remember, or grasp through analogy. If we can make this preliminary connection, the meaning-making process continues. If there is nothing to connect with, we are likely to give up and stop trying. This failure to continue the meaning-making process can result in a shallow and rather negative experience, and one which might well reduce our self-confidence.

However, assuming that a basic link is made (we recognise that this is a Tudor costume, for example, or we are intrigued by the jewels on the dress), we begin to look further at the details of the painting to see if we can continue the process of recognition and meaning-construction. We might observe any detail of the painting (hairstyle, make-up, dress, jewellery, hands, feet, map, sky). We begin to attribute meaning to these details according to what we already know.

Children, for example, who frequently observe that the woman is wearing a great many jewels, are intrigued, and deduce that she must be rich; they see that she is wearing an elaborate dress of a fine material, and has something like a crown on her head, and think that she may be a queen. It is clear that the style of the clothes is not contemporary, but historic. The woman is standing on a map. We may recognise some of

PLATE 1. *Elizabeth I* (circa 1592) by Marcus Gheeraerts the Younger (NPG 2651). By courtesy of the National Portrait Gallery, London

the place-names as from southern England. From all of this, most people conclude quite rapidly that the image is probably of an English queen, from a previous historical period.

The sky behind the figure is different on both sides of the painting. There are clouds and a suggestion of lightning on one side, and the sun is attempting to shine through the clouds on the other. If we recognise the queenly figure as Elizabeth I (and many people do, as the image of the Tudor queen is relatively familiar through having been seen in history books, in films and on television), we may be moved to ask ourselves what the sky might mean. Sometimes, in discussing the painting, a prompt is helpful at this point. A little historical knowledge is needed to link the image of Elizabeth to war with Spain, and a little art historical knowledge is needed to know both that, and how symbols can be used in paintings. However, it is a relatively simple step from this to understand that the sky is used in the painting to symbolise Elizabeth leading England through the storms of war to the sunny days of peace.

The metaphors are the same in late twentieth-century England. If it is known that at the end of Elizabeth's reign there was a continuous question as to who would succeed her, it is not difficult to conclude that the painting is a propagandist image, demonstrating her wealth, standing and military power. The painting asserts her continued fitness to rule.

This process of attributing meaning depends on prior knowledge; how far it goes depends on how much is known, and how well we are able to interrogate and use what is known. Information from a range of fields of knowledge might contribute to the construction of meaning in relation to this painting. These might include English history, English myth, English painting, portraiture in general, clothing and costume, literature (especially Shakespeare), queens and their images, and children's stories.

Attitudes and beliefs also affect the interpretation of what is seen and known. Ardent republicans may interpret the image differently from passionate royalists; feelings about the importance of the incident in the English Channel during the invasion by the Spanish Armada in 1588 are no doubt linked to nationalism and patriotism. Ideological convictions are deeply embedded in individual psyches and influence how meaning is made, and interpretations develop.

As constructivist learning theory confirms,[1] the construction of meaning depends on prior knowledge, and on beliefs and values. We see according to what we know, and we make sense or meaning according to what we perceive. In contrast to those who hold that knowledge is a body of objective facts, external to the knower, constructivism asserts that knowledge exists only through the process of knowing, and that meanings are constructed by individuals, and not found 'ready-made'. Thus in coming to know the Ditchley Portrait, an individual response to the painting emerges, related to the

1 G. Hein, 'The Constructivist Museum', *Journal of Education in Museums*, 16, 1995, pp. 21-23; M. Priestl and J. Gilbert, 'Learning in Museums – Situated Cognition in Practice', *Journal of Education in Museums*, 15, 1994, pp. 16-18; T. Russell, 'The Enquiring Visitor – Usable Learning Theory for Museum Contexts', *Journal of Education in Museums*, 15, 1994, pp. 19-21.

2 M.Csikszentmihalyi and K. Hermanson, Intrinsic Motivation in Museums: Why does one Want to Learn?', in J. Falk and L. Dierking (eds), *Public Institutions for Personal Learning* (Washington: American Association of Museums) 1995, pp. 67-77.

3 K. B. Jensen, 'Humanistic Scholarship as Qualitative Science: Contributing to Mass Communication Research', in K. B. Jensen and N. W. Jankowski (eds), *A Handbook of Qualitative Methodologies for Mass Communication Research* (London and New York: Routledge) 1991, pp. 17-43, at pp. 41-43.

resources and skills the viewer can bring to the process of looking.[2]

The process of making sense of a painting is a process of looking from the whole to the detail and back again. It is a process of oscillation between observation and deduction, a dialogue. The process is dialogic.[3] In the Ditchley Portrait, for example, if we look closely at the feet, we notice that they protrude from underneath the skirt of the Queen in a very unrealistic manner, and don't really look as though they support the body. Do the feet have a function other than that of supporting the body? The feet do, in fact, serve to draw attention to the origins of the painting. Marked between them is the name of Ditchley, the name of the country house belonging to Sir Henry Lee who commissioned the painting as a courtly gift for the Queen when she visited the estate in 1592. The feet and the way in which they are painted raise questions. Once the answers to these questions are found, aspects of the historical context of the painting, of Elizabethan portraiture, and of the life of a Tudor courtier emerge. Thus a focus on the detail contributes to our understanding of the whole, and the portrait begins to be placed within its social context.

As the portrait becomes more familiar, we are able to consider it as part of the whole of society both now (today) and in the past. We relate the painting to what we know now. We recognise it as an image of a queen and as a portrait. We place the portrait within a suite of images (photographs and painting) of queens. Both the concept (queen) and this idea of representing it through an image are familiar to us in the West in the late twentieth century.

At the same time, we relate the painting to what we know of the past. The image of the Queen is placed within our ideas about and knowledge of Tudor royalty. If we have a developed and sophisticated knowledge of the way in which the cosmos was imagined during the Tudor period, we can see evidence in the painting for the Great Chain of Being, and the place of the Queen within this. If our image of Tudor England is less well-informed, we will still relate the portrait to what we do know, calling on our impression of the past. At the same time, the painting will itself influence our imagining of the past. Unless a rigorous process of interrogating these imagined impressions of the past is undergone, assessing this image in comparison with others, and relating the information gathered from the image to information gathered from other sources, then our views may be and remain incorrect. For example, we may assume that the jewels sewn onto the dress are paste, because we can't imagine that anyone would really do this with genuine precious stones. It would take either a friendly expert, or some historical research, to correct this impression.

The process of making meaning moves both between the whole and the part of the object and between the present and the past, simultaneously. A dialogue is established

between the whole and the part, the past and the present, which enables continual checking and rechecking, revision of ideas, trying out of new ones and rejection of those that don't work.

The process of constructing meaning from the painting[4] is circular and dialogic. We are in a question-and-answer mode, a continuous process as the answers build on those questions that have already been asked and answered. This circular movement involves both the whole and the part, but also the present and the past. Meaning is constructed through this circular action, with modifications to the sense we construct being made constantly.

THE HERMENEUTIC CIRCLE

The process of meaning-making is explored in hermeneutic theory. 'Hermeneutics', or philosophical interpretation, is the name of the movement in philosophy that is concerned with how meaning is made.[5] Two of the major figures are Gadamer and Dilthey, both twentieth-century German philosophers, but the roots of the movement go back much further.

The word 'interpretation' is used in this philosophical movement to mean the process by which individuals make sense of their experience. In discussing how we relate to objects (as above with the Ditchley Elizabeth), we were talking about what we saw and what sense we made of what we saw. The process of interpretation focused on the mental activity of the viewer.

In hermeneutics, then, meaning is constituted through a circular action, the hermeneutic circle, where understanding develops through the continuous movement between the whole and the parts of a work, where meaning is constantly modified as further relationships are encountered.

The process of constructing meaning is like holding a conversation. Any interpretation is never fully completed.[6] There is always more to say, and what is said may always be changed. The hermeneutic circle remains open to these possibilities, and in this sense, meaning is never static.

All interpretation is, therefore, necessarily historically situated. Our own position in history, our own culture, affects meaning. Meaning is constructed through and in culture. Perception (what we see), memory (what we choose to remember) and logical thinking (the sense we choose to attribute to things) differ culturally because they are cultural constructs.[7]

For hermeneutic philosophers, meaning-making is shaped by the inevitability of prior knowledge; the effect of tradition, the past as it works in the present; the prejudices and biases that are inevitably part of being human and the capacity to interrogate the past and to distinguish between productive and non-productive pre-conceptions (which are based on our prior knowledge).[8] This hermeneutic approach to knowledge and understanding is very close to that of constructivist learning theorists: both propose that knowledge emerges

4 Here I am discussing the interpretation of a painting in relation to the image in the painting. It would also be possible to interpret the painting as an object, in terms of its materials, provenance etc., as it is for any object.

5 See the following by H. G. Gadamer: *Philosophical Hermeneutics* (Berkeley: University of California Press) 1976; *Reason in the Age of Science* (Cambridge, Mass. and London: the MIT Press) 1976; and 'The Historicity of Understanding', in P. Connerton (ed.), *Critical Sociology – Selected Readings* (Harmondsworth: Penguin) 1976, pp. 117-33 (first published 1965).

6 'The discovery of the true meaning of a text or a work of art is never finished: it is in fact an infinite process' (Gadamer, *Critical Sociology*, p. 124). As errors in understanding are eliminated and as new sources of knowledge emerge, so meaning is a continuing process of modification, adaptation and extension. The hermeneutic circle is never fully closed, but remains open to the possibilities of change.

7 J. K. Ogbu, 'The Influence of Culture on Learning and Behaviour', in J. Falk and L. Dierking, *Public Institutions for Personal Learning* (Washington, DC: American Association of Museums) 1995, pp. 79-96.

8 S. Gallagher, *Hermeneutics and Education* (New York: State University of New York Press) 1992.

Figure 1.
Processes of interpretation: hermeneutic circles from Hans–Georg Gadamer

through the interpretation of experience made by the knower, and is not an objective body of facts that can be transmitted.

Both assert that knowers, or learners, or interpreters are active in the process of making sense of experiences (including the formal or informal experience of learning). Both suggest that knowing is culturally inflected, and that in this sense knowledge is relative. Both stand against a transmission view of teaching or communicating. This transmission model works on the basis of knowledge as external to the knower, as a discrete body of objective facts that may be transmitted through a linear process to the knower or receiver, who passively accepts the information. Both hermeneutics and constructivism wish to move away from this behaviourist model of learning, which has developed from a stimulus-response view of teaching and learning processes.

INTERPRETIVE COMMUNITIES

To say that each individual makes sense of the world in their own way is to become open to the charge of extreme relativism. So far we have been talking about meaning-making as though it was an individual process, and although it often feels as though it is, it is in fact a social process. Our individual strategies for making sense of experience are enabled, limited and mediated through our place in the social world.

We are all creatures of our particular time and place; we think and feel what appears to be natural to us, but this 'common sense' is only 'natural' to our particular time period, geographical location, background and history.[9]

9 C. Belsey, Critical Practice (London and New York: Methuen) 1980.

Given that the process of interpretation involves prior knowledge, and that the world is known through culture, our interpretation will be that which fits our particular time and place in the world. What we know is what we need to know to enable us to take our place in a particular society or group.

Different societies or groups require different knowledge bases and skills in order to exist. For example, on a recent visit to New Zealand, I felt 'out of it' because I didn't know about the musket wars, or the Treaty of Waitangi. If I went to a football match I would not know how to evaluate the game, and I would not know the histories of the individual players. All communities, however defined, have their own ways of knowing, their own knowledge base and their own strategies for interpretation.

Literary theory[10] tells us that we can identify 'interpretive communities' to the extent that we can identify a community of people who share interpretive strategies. Interpretive communities are made up of those who share interpretive strategies for reading objects, for identifying their significance and for pointing out their salient features.

These strategies exist prior to the act of reading and therefore determine the shape of what is read. That is, you come to a painting (a book, an experience) with a set of 'reading strategies', and thus you know what to look for. According to what you look for, you will see certain things in certain ways.

Thus it is the interpretive strategy that determines the meaning of the object, and in many ways determines how the object is seen and what counts as the object in the first place.

For example, Hinemihi is a Maori Meeting House now standing in the grounds of Clandon Park, a National Trust property near Guildford. To the National Trust, the house is seen as 'this work of art in our care', a collection of carved posts for which they have responsibility and a duty of custodianship. To the Maori community in England Hinemihi is someone who you should come and see when you are sick and unhappy and who will restore your sense of Maori identity. She is Hinemihi, an important and well-remembered woman of the Ngati Hinemihi tribe, and a place to bring visiting Maori relatives or friends.[11]

These two very different interpretations of Hinemihi stem from different attitudes to and definitions of art, different positions in and knowledge of history, and different attitudes to the role of the past in the present. These knowledges, positions and attitudes result in different interpretive strategies, and we can immediately identify two very different 'interpretive communities'. Each knows the object in different ways, and those ways are both personal and social. The 'object' that is seen, which is the one and the same painted wooden structure, is not the same, but is both perceived, remembered and logically considered in completely different ways, and yet to each of these groups of interpreters, their way is 'common sense'.

10 Interpretive communities are made up of those who share interpretive strategies for writing texts, for constituting their properties and assigning their intentions (S. Fish, *Is There A Text in this Class? The Authority of Interpretive Communities* (Cambridge, Mass. and London: Harvard University Press) 1980, p. 171).

11 E. Hooper-Greenhill, 'Museum Learners as Active Post-Modernists: Contextualising Constructivism' *Journal of Education in Museums*, 18, 1997, pp. 1-4. See the whole of this volume for useful and interesting papers about researching museum learning.

The concept of 'interpretive communities' begins to explain this quite well. It is within interpretive communities that the meaning-making of an individual is tested, revised, supported and developed. The interpretive community both constrains and sets limits for meaning, and enables meaning.[12] Interpretive communities are not stable, but may change as people move from one to another. They may grow and decline as other things change.

INTERPRETATION
IN THE ART MUSEUM

What are the implications of all that we have discussed for interpretation in the art museum? There are three main ideas to be considered: the relevance of hermeneutic approaches to understanding of the process of meaning-making, the importance of conceptualising the audience as active in this dialogic process, and the concept of interpretive communities. One way of bringing this all together is to consider how interpretation is understood at the present time in the art museum.

There is a major difference in emphasis in the way the word 'interpretation' is used in theory (in hermeneutics and constructivism) and in the way in which it is used in the museum. 'Interpretation', as understood by hermeneutics, is the mental process an individual uses to construct meaning from experience; you are the interpreter for yourself. Interpretation is the process of constructing meaning. Interpretation is part of the process of understanding.

In the museum, 'interpretation' is a process that is undertaken on behalf of someone else. Museum staff undertake interpretation for museum visitors. In other words, 'interpretation' is something that is done for you, or to you. A museum interpretation officer could be one of many things – an education officer, a designer, or an exhibition officer. The emphasis is on the mediation between the collection and the visitors, but, mostly, with little understanding of the varying interpretive strategies which visitors might use.

Traditionally, in museums, the implicit model of communicating with the public is that of the transmission of objective bodies of authoritative facts to passive receivers. A more cultural and constructivist model may well be in place in the education departments, but does not always influence thinking about visitors in curatorial circles.

If the ideas discussed in this essay are accepted, then new ways of establishing and maintaining dialogues with visitors will be necessary, and new ideas about how to link to the interpretive strategies employed by different communities will need to be developed. Some of the methods employed in the Young Tate project offer examples of some ways forward.

12 S. Fish, *Is There a Text in this Class?*, p. 332. 'Systems of intelligibility (e.g. literary system) constrain and fashion us and furnish us with categories of understanding with which we fashion the entities to which we then point.'

FURTHER READING

M. A. Boden, *Piaget* (London: Fontana) 1995.

J. J. Brody, 'Meanings of Things', *Museum News*, 70(6), 1991, pp. 58-61.

M. Csikszentmihalyi and R. Robinson, *The Art of Seeing* (Malibu, California: J. Paul Getty Museum and Getty Centre for Education in the Arts) 1990.

W. Dilthey, 'The Rise and Fall of Hermeneutics' in *Critical Sociology: Selected Readings*, ed. Paul Connerton, (Harmondsworth, Middlesex: Penguin Books) 1990, pp. 104-16.

J. Falk, and L. Dierking, *The Museum Experience* (Washington, DC: Whalesback Books) 1992.

J. Falk, and L. Dierking, (eds), *Public Institutions for Personal Learning: Establishing a Research Agenda* (Washington: American Association of Museums Technical Information Service) 1995.

G. Hein, *Learning in the Museum* (London and New York: Routledge) 1998.

E. Hooper-Greenhill, *Museums and the Shaping of Knowledge* (London: Routledge) 1992.

E. Hooper-Greenhill, 'Learning from Learning Theory in Museums', *GEM News*, 55, 1994, pp. 7-11.

E. Hooper-Greenhill, 'Perspectives on Hinemihi – a Maori Meeting House', in T. Barringer, and T. Flynn, *Colonialism and the Object* (London: Routledge) 1998, pp. 129-43.

C. Husbands, 'Objects, Evidence and Learning: Some Thoughts on Meaning and Interpretation in Museum Education', *Journal of Education in Museums*, 13, 1992, pp. 1-3.

C. Husbands, 'Learning Theories and Museums: Using and Addressing Pupils' Minitheories', *Journal of Education in Museums*, 15, 1994, pp. 5-7.

W. Iser, 'Interaction between Text and Reader', in J. Corner, and J. Hawthorn, (eds), *Communication Studies: an Introductory Reader*, (London: Edward Arnold) 1985.

L. C. Roberts, *From Knowledge to Narrative: Educators and the Changing Museums* (Washington: Smithsonian Institution Press) 1997.

J. Roschelle, 'Learning in Interactive Environments: Prior Knowledge and New Experience', in J. Falk, and K. Dierking, (eds) *Public Institutions for Personal Learning*, (Washington: American Association of Museums) 1995, pp. 37-51.

L. Silverman, 'Visitor Meaning-making in Museums for a New Age', *Curator*, 38 (3). 1995, pp. 161-70

E. Sotto, *When Teaching Becomes Learning: a Theory and Practice of Teaching* (London and New York: Cassell) 1994

L. P. Steffe and J. Gale, (eds), *Constructivism in Education* (Hove: Lawrence Erlbaum Associates) 1995.

L. S. Vygotsky, *Thought and Language* (Cambridge, Massachusetts: The MIT Press) 1962.

L. S. Vygotsky, *Mind in Society: the Development of Higher Psychological Processes*

(Cambridge, Massachusetts and London: Harvard University Press) 1978.

J. Wolff, *Hermeneutic Philosophy and the Sociology of Art – an Approach to Some of the Epistemological Problems of the Sociology of* *Knowledge and the Sociology of Art* (London and Boston: Routledge and Kegan Paul) 1975.

D. Worts, 'Extending the Frame: Forging a New Partnership with the Public', *New Research in Museum Studies*, 5, 1995, pp. 164-91.

Chapter
Seven

★

STORY

Taking Stock

Naomi Horlock

REFLECTING ON THE PAST AND RE-SHAPING FOR THE FUTURE

The Gallery's closure to the public for re-development work in April 1997 provided an opportunity in Young Tate's fourth year for reflection and research. It enabled the Gallery to consult with young people and youth agencies with the intention of developing a more effective approach to peer education.

During this closure period new and improved services for visitors were put in place including a new cafe-bar, bookshop and group reception area on the ground floor; an additional passenger lift was installed, and the foyer re-modelled. The first and second floor gallery spaces remain as they were, with the addition of information rooms. A new education studio and educators' resource room has been added to the first floor, the former education studio on the second floor having been converted into an office area. The previously undeveloped fourth floor has been transformed into new gallery space, an auditorium and seminar rooms.

Young Tate collaborated with Merseyside Youth Association and Liverpool's Bluecoat Arts Centre on a five-day summer project at the Bluecoat. With no art on show at Tate Liverpool, the project focused on an exhibition at the Bluecoat. Two challenging and innovative Young Tate projects were also set in motion: the Young Tate *Newsletter*, a collection of articles written by Young Tate members about modern and contemporary art; and the Young Tate web-site, an interpretation project which focused on the work of a living artist in the Tate's Collection.

During this year the building was completely inaccessible to the public, and workshops

were therefore not possible. The programme of regular activities was suspended until re-opening, and Young Tate's resources became focused on retaining existing members.

The five-day summer project focused on the Bluecoat Arts Centre's summer exhibition, a celebration of the 30th anniversary of the Beatles' famous 'Sgt. Pepper's Lonely Hearts Club Band' album sleeve, designed by artists Peter Blake and Jann Haworth. The 'Sgt. Pepper' exhibition re-interpreted the album cover in the main gallery using new heroes and icons nominated by artists. Record sleeves and other graphic re-workings of the 'Sgt. Pepper' cover were also shown. Working with a team of artists and young people, and taking the 'Sgt. Pepper' cover as a starting point, young people were encouraged to develop ideas about their own cultural icons using prose, poetry and performance, combined with photography, video and sculpture. Thirty young people were introduced to some of the ideas behind the album cover, exploring issues raised by the exhibition through talks and open discussion with the exhibition's curator, a lecturer in popular music, and artists involved in making the installation.

Responding to two works by Richard Hamilton – *The subject* (1988-90), and *The state* (1993), scheduled to be shown as part of the 'Urban' display when the Gallery re-opened – a group of five young people worked with Liverpool multimedia producers Amaze Ltd, and the Gallery's Education Department to make a web-site. The Internet project is a significant marker in the development of peer-led work within Young Tate, and the level to which young people are empowered to take on more responsibility. The project required a considerable amount of commitment from those involved over an intensive six-week period. The venue for the project was not the Gallery, but the offices of Amaze, a commercial company with little experience of working with young people. The Group, aged seventeen to twenty-two, took time to adapt to this new learning environment.

The project had a shaky start. The young people were either at work or at school during office hours, making it very difficult to get everyone together at the same time. The budget for the project allowed for a

professional web-site designer to be involved two days a week for a six-week period. The first two weeks of the project were a string of confused meetings attended by too few young people. However, the project began to come together at the start of the summer holidays when two members of the Group were able to commit more time and, more significantly, to take the lead in co-ordinating the roles of each member of the project team.

Much of the Gallery's work with young people has been centred on facilitating and supporting those members of Young Tate involved in leading workshops. The brief for the Young Tate Internet project, although focused on interpretations of work in the Tate's Collection, was written by members of the project team, their ideas supported and developed by multimedia specialists, with Tate staff taking a back seat. Previous curating and interpretation projects, although allowing individual and collective creativity of response, were often heavily constrained by the Gallery's agenda, for example, the 'Testing the Water' display. It is fair to say that despite the high level of technical support and advice from Amaze, and the Gallery's input on various levels, the young people involved were largely self-contained and self-motivated. As a unit and as individuals they organised themselves, and as a consequence the finished 'product' is fresher and less 'Tatified'.

Tate Liverpool re-opened to the public in May 1998, and the new programme for year five implemented changes in response to feedback received from young people before the Gallery closed. Progression, learning and development had been identified by young people as important reasons for attending Young Tate, and these elements are now seen as underpinning future young visitor services at Tate Gallery Liverpool.

Feedback also suggested that the broad 'fourteen to twenty-five' age range worked well over a two- or three-day project, but that a more age-specific approach should be applied to the monthly weekend workshops. Young people were keen to see the workshops tailored to the interests of particular age groups. Several Young Tate members had 'grown up' with the

programme, and as such were able to draw on their own experiences. They pointed out that a seventeen-year-old art student may not want to participate in a practical element at all during a workshop, preferring instead to focus on increasing their understanding and knowledge of artists' work in the Gallery. They felt fourteen-year-olds were more likely to be attracted by the opportunity to make work of their own. Young Tate's re-opening programme now targets five Saturday workshops per year at fourteen- to sixteen-year-olds, and five at seventeen- to twenty-year-olds.

Older members of Young Tate had been enthusiastic about raising the level of critical debate around twentieth-century art amongst young people. They recommended Young Tate run more events that explore in greater depth the issues raised by the Gallery's displays and exhibitions. Twilight sessions called Head to Heads, with guest artists and speakers, were introduced to the programme in 1998 for the sixteen to twenty-five age range.

PEER EDUCATION AND TRAINING

During the Gallery's closure period, developing the role of young people as peer educators had become the focus of research. The Youth Clubs UK Peer Education Conference in November 1997 had helped to place the Gallery's work with young people in the wider context of national youth work.

Initial discussions with the British Youth Council in year five led to the planning and implementation of a training course for Young Tate workshop leaders. This course conformed with the British Youth Council's agenda by involving participants in its design, content and delivery. The course was designed largely by three members of Young Tate in consultation with the British Youth Council's Training Officer, Chris Vallance, and with the support of Gallery staff. A further twelve young people responded to a flyer sent out to all Young Tate members through the mailing list. Participants, all aged sixteen and above, were paid travel expenses for their attendance which took place over six three-hour evening sessions and two full day sessions during July and August 1998.

Gallery staff, freelance artists, and sometimes the young people responsible for designing the course, led sessions with young people to help them develop a familiarity with the Gallery and the twentieth-century art it shows. Young people were introduced to all the displays and exhibitions through talks and discussion with curators and specialists, and through workshops with artists and educators which explored the ideas and issues raised by the work on display. Workshops focused on developing group work and leadership skills, building confidence through practice sessions aimed at introducing young people to some of the methods and approaches used for

working with groups in the Gallery. The young people were asked to work in pairs on an 'assignment', from which they were to suggest ideas for workshop-based tasks around a particular artist or theme, and which they then 'tested out' on other members of the group.

At the end of the course, Young Tate leaders were employed to help plan and lead Young Tate workshops with artists and Gallery staff. It is still too early to assess the full effect of the training course at this time. What is already clear, however, is that the course participants (only one is an original member of the Advisory Group) have become an informed and articulate core group. To date nearly all the participants of the course have experienced at least one workshop in their role as a group leader. They recognise that the course is only the first step in the development of their workshop skills. An ongoing evaluation process of the course's design, delivery and effectiveness is currently under way with the Young Tate leaders. A second training course will take place in year six, with a new group of Young Tate members who will be recruited to expand the existing team.

CONCLUSION

The introduction of the training course for Young Tate workshop leaders has been instrumental in re-defining the quality and depth of programming. The course has extended and professionalised the role of Young Tate workshop leaders, placing gallery workshop methodology at the centre of participants' learning experience.

The implementation of the course has allowed young people to be involved in more specialist aspects of the programme beyond weekend and holiday projects. Young Tate leaders are increasingly involved in helping to plan and facilitate work with youth groups, and with professionals working with young people in a range of youth work settings. Where possible, and appropriate, Young Tate leaders and the Young Tate Co-ordinator have been liaising and developing work with organisations such as H.M. Young Offenders' Institute Thorncross, the Duke of Edinburgh Award Scheme, the Weston Spirit, the drugs agency Arch Initiatives, Social Services, and non-mainstream education.

In addition, four Young Tate workshop leaders have contributed to the planning and delivery of the Gallery's DfEE Funded Study Support project with two Liverpool secondary schools. The project has used Young Tate as a model for developing a culture of peer-led work within a 'live' and digital interpretation project, centred on work in the display 'Modern British Art'.

A Young Tate member is part of Tate Gallery Liverpool's Visual Impairment Advisory Group, and the Gallery is represented on Liverpool Architecture and Design Trust's 'Young Urbanists' steering group.

Planning is well under way to improve and extend Young Tate's programme for the future. At the heart of the Gallery's young audience development strategy is a will to make the art of our time relevant, accessible and enjoyable to young people. Through peer education, consultation and collaboration with young people and youth agencies, Young Tate is committed to widening the Gallery's appeal to young audiences. In order to establish their role as places of life-long interest as well as life-long learning, museums and galleries need to develop their relationship with young people beyond the remit of the educational visit.

Tate Gallery Liverpool's Young Tate programme has developed an approach to youth audience development which gives young people direct access to the art, and to the tools required to help unpack it. By working closely with young people over the last five years, the Gallery has learned to embrace change and to take risks. Given the opportunity to work with an institution, and to develop their knowledge of its purpose and operation, young people become informed critics. There are no easy solutions to the problem of attracting and maintaining young audiences. Long-term sustainable programming with young people at the centre of the planning process works over time to build familiarity and trust, bringing with it unexpected rewards.

Tate Gallery Liverpool has learned that to attract and maintain young people's interest in the art it shows, the Gallery must establish itself as an alternative learning resource relevant to, but at the same time removed from, the world of formal education.

Young Tate Web-site

Liza Lemsatef

In November 1997, with new development work giving the Gallery the appearance of a construction site, Tate Gallery Liverpool's outreach programme involved Young Tate doing some construction work of our own, researching, designing and authoring a web-site to promote debate around contemporary art in the Tate's Collection.

The web-site project was a well-timed initiative from my perspective, as I was becoming a little restless working full-time in a non-art-related job, despite having concentrated on digital art and interactive multimedia during the final year of my fine art degree.

The project provided me with the opportunity to work in the medium again, with the unique advantage of being based in the professional environment of Amaze Ltd, a digital media company. Research on the web unearthed some very disappointing offerings from international galleries and museums. I found that many museums on-line proudly presented convincing 'virtual' galleries, consisting invariably of thumbnail sized GIFs (digitised photos of the work) alongside uninspiring text lifted from a catalogue or gallery label. Even an elaborate site providing a walk-round of the gallery operated more as a showcase for the technology rather than encouraging an engagement with the work.

We aimed not to substitute a real gallery experience, or to present an electronic catalogue, and not even to recreate the gallery in virtual space. The site was envisaged as being more akin to a peer-led workshop, written from the perspective of a group of Young Tate members aged

seventeen to twenty-four. Targeted at young people, we worked on the principle that the viewer should not be a passive receiver of images and information; rather, through interaction, the user could actively engage in dialogue with the works and explore issues further for themselves. We selected three works by Richard Hamilton: *The state* (1993) and *The subject* (1988-90) from the forthcoming 'Urban' display, and *The citizen* (1981-83) last shown at Tate Gallery Liverpool as part of 'Moral Tales'. Investigating Richard Hamilton's series about Northern Ireland allowed us to investigate three works at once, allowing scope for comparison and cross-referencing. The political subject matter raised interesting questions and posed the challenge of presenting an unbiased perspective. We also found fascinating the way Hamilton's striking images are developed using a variety of media.

The first stage of the project involved researching on the World Wide Web and conceiving ideas for 'treatments' for the work, individually and in groups. At this stage discussion was certainly interesting but little evidence of work was produced, and attendance at meetings was sporadic. With only two-thirds of project time left we required a more structured approach to start making our ideas manifest in digital form.

I wrote a brief that helped consolidate what we were working towards, and took the initiative to co-ordinate the project. Assigning roles as part of the web-site team allowed everyone to concentrate on their own interests and abilities, and reassured those initially concerned that they had no experience working on computers. A 'shout out' session generated ideas for subject areas to explore and gave us a framework.

Group members accepted as much or as little work as they were prepared to undertake, tempered by their commitments to college work, employment, and so on. I began to prepare task breakdowns and agendas to prioritise work, and organised meetings at Amaze, allocating tasks and deadlines, and drawing up regular status reports. Establishing effective communications within the Group was essential, as the project was to be realised, effectively, in our spare time over a six-week period. Those unable to attend meetings were informed by telephone of developments and approaching deadlines. They were also urged to keep in contact with myself so, armed with a clear overview of how the site was shaping up, I could attend meetings at intervals with Amaze and Gallery staff, presenting work for discussion and reporting back to the Group.

Real progress was made with tenable goals set according to each individual's personal interests and skills. The majority of the Group chose to offer responses through poetry, creative writing and critical analysis, working at home and using time at Amaze to research on the web or refer to resource files we were compiling in our work area. We discovered our schedules did

not overlap very often. I, for example, was still working full-time, which meant preparing a lot of digital material on my home PC in order to make the most of time with access to facilities and technical guidance at Amaze. Living with one of the Group members (my sister Soraya) was helpful in developing ideas, and Group members who felt unable to contribute to the design or production of digital media were still able to offer valuable feedback and test the prototypes I presented at meetings. Regular feedback during the construction of the web-site ensured the interface was user-friendly and appealing to young people.

The structural hierarchy of the site was modified several times to give precedence to Hamilton's paintings, which were presented so the user could choose the order in which to view them. The series was treated with innovative technology discovered on the web, which allows the user to zoom in and move around a high resolution magnified view of the work. The rest of the site was structured in such a way that allows each user to approach the different elements and refer back to the work in an idiosyncratic, non-linear way. Working closely with programmer Adam Todd, interactive media objects were produced for the site.

Fragments of research and ideas generated at meetings were, during the editing process, condensed into bullet-points (thus avoiding large chunks of catalogue-style text). Statements of fact or opinion, questions, or quotations from newspaper reports and literature scroll at random along the top of the work being viewed, in an attempt to encourage the user to consider the works' conceptual, contextual and formal elements from the outset. Concise statements relating to one or all three of the Hamilton works, with the aid of the computer, appear juxtaposed in random combinations producing infinite new readings. Without dictating any one point of view, the sense of each line shifts constantly, promoting creative interpretation on the part of the viewer. In another part of the site, haiku combinations produced by 'random generator' are presented. The backgrounds created for the site reflect Hamilton's work, as themes of territory division and confinement are suggested visually, to layer meaning and complement the textual pieces which form the core of the site.

The Amaze 'navahedron' is adapted to compose a 'polypoem', words arranged and read in a polylinear/multilinear way. An interactive work, *'This is the voice of...'*, raises questions about a hypothetical fourth image in Richard Hamilton's series – who is left out of the frame? What would happen if the viewer were the protagonist? Inviting feedback and input from users provides scope for expansion and production of collaborative work, developing the culture of exchange between young people and echoing the Young Tate's approach to peer-led education.

The Young Tate web-site can be found on: http://www.amaze.com/tate

Young Tate Workshop Leaders' Training Course

The following extracts are taken from papers written by Emilia Eriksson and Anitha Darla as part of the evaluation of the Young Tate Workshop Leaders' Training Course.

I was involved in helping to plan the course with two other Young Tate members, Elly and Liza. In the early planning stages we were able to get some help from the British Youth Council in the form of Chris Vallance, their Education Officer. The main aim of the course was to strengthen and develop peer-led education within Young Tate. Chris's experience of peer-led education and his independence from the Tate Gallery meant that he was better equipped to help us to structure our ideas.

The course needed to be encouraging and confidence-building...We all felt that one of the largest issues we had to focus on was what kind of skills were needed to be a workshop leader. This was by far the most difficult task, and after lengthy debate we came up with a set of aims and objectives.

Throughout the course we asked several people who were either artists, curators or in some way connected with Tate Liverpool to attend our sessions and help us with different aspects of the course. Personally I felt that this was a very giving experience. It was interesting to interact with these specialists, and experience their points of view about the art on show.

I was rather anxious as to whether the Group would be able to work together collaboratively. Luckily the Group was marvellous, and socially we all became friends very quickly. The learning process has not ended for us as now we have to put what we've learned into practice.

Emilia Eriksson

I had no idea what to expect. I remember walking into the newly refurbished Tate Gallery for my first session feeling very nervous and tense. The course leaders did not allow these awkward feelings to set in. They mingled with the nervous group, easing tension to provide a friendly and relaxed atmosphere that set the tone for the whole course.

Like many of the people who attended, I had originally come along to boost my confidence and gain experience. As well as achieving this, I gained a variety of new skills and met new people.

The course enabled all participants to develop a familiarity with the Gallery. The Group began to explore the themes behind the work on display. We got to grips with all parts of the Gallery including staff, curators and freelance artists. The best thing about the course was that no one's views or opinions were dismissed – people felt comfortable to put forward their views. There was no pressure to make people feel awkward.

After completing the course I felt I had some of the skills necessary to contribute more effectively to the planning and running of workshops. I found people had really enjoyed themselves, and that their only real criticism about the course was that it was too short.

All the skills and techniques I had learnt were put into practice when I took my first workshop, 'The Shock of New', with artist Gill Nicol. We discussed artists and the controversy in modern British art, and all in all the workshop went well.

Anitha Darla

The following quotes are taken from a taped transcription (January 1999) of an evaluation session with young people who had completed the Young Tate Workshop Leaders' Training Course. The session was led by Gill Nicol, a freelance artist and educator. The session also focused on ideas for improving the course, reviewing the current programme for young visitors, and the planning programme for 1999-2000.

PARTICIPANTS' COMMENTS:

I did the course to build up confidence and communication skills.

I was curious as to what it [the course] involved. I think you learn more about art history and the art world. The Tate gives you an overall view of how the art world works; it builds on a process and enables you to teach others.

PARTICIPANTS' COMMENTS:

I've got a lot more confidence…in speaking about art and talking to people.

You are sharing your views…

It's taught us that there's not just one view – lots of different people's opinions are valid…but it's taught us to look at art with our own eyes.

Working on a workshop with different age ranges, you get a lot of satisfaction in hearing different views. The things they say…help you cope in different situations.

I'll remember just one person who says something wonderful about the work. It builds up my confidence as well – that there is always an opportunity to learn.

The Young Tate course was really well structured.

The course requires commitment…

I like the idea of getting feedback from our different workshops – to compare our different experiences.

Because I've been involved in planning, I now have experience, and want to lead a workshop with an artist as collaborator…

It's better when there's a mixture of men and women, and different age ranges with Young Tate.

Teamwork is a very big strength; if there are any problems you are able to talk through them…It's good practice in speaking in front of a group, and stops you being overwhelmed by people.

The Shape of Things to Come?

David Anderson

Will the future be any different from the present? There are many different young people and many different museums, many varieties of the present as well as many possible futures for young people and museums. Can we summarise even the current situation, let alone the future? But without such a summary, there is no framework for discussion of change.

One of the most serious obstacles is the lack of research in the museum sector or elsewhere to underpin analysis. As David Cannon noted in a recent Demos publication on young people's attitude to work, 'There has been very little money to fund youth research. The only exception has been marketing research focusing on how to sell things to teenagers and young adults. Generation X (young men and women – generally better educated than the average, between the ages of eighteen and twenty-nine) is especially hard to find out about. Researching the very private world of young adults requires tools that pry below the well managed exteriors most teenagers and even parents typically deal with. Questionnaire surveys, favoured by academics and marketing researchers because of their statistical validity, have provided us with little real understanding.'[1]

In part the weakness of the research base for study of young people's lives, and of their relation to museums and other art institutions, is a reflection of the relatively low priority given to young people in public policy, and the fragments of public sector provision for their learning and other needs. Regional Arts Boards fund arts workers and artists to work in the community, whilst the youth service is

[1] David Cannon, *Generation X and the New Work Ethic, The Seven Million Project Paper No. 1.* (London: Demos) nd, p. 20.

2 J. Harland, K. Kinder and K. Hartley, *Arts in their View: A Study of Youth Participation in the Arts* (Slough: National Foundation for Educational Research) 1995, pp. 12-13.

concerned primarily with programmes of social and personal education.[2] There is no common curriculum for informal youth arts, comparable with that for schools, to which museums can relate. Despite growing recognition by government of the social and economic consequences of exclusion of large numbers of young people from the established institutions of society, funding for young people's provision – and hence also for research in the field – remains very limited.

What do the statistics tell us? Stuart Davies, in a study for the Museums and Galleries Commission (MGC) in 1994, found that along with older adults, young people aged 15 to 24 are the section of the population least likely to visit museums.[3] However, a recent report by the National Foundation for Educational Research (NFER) provides the best statistical evidence we have of young people's participation in museums and galleries. It found that 7% of young people aged 14 to 24 had visited galleries or exhibitions in the last year, of whom 12% (nearly double the average for the age group) were unemployed, and had visited the institutions in their leisure time. Only 2% were still at school; those in their early twenties and those from socio-economic groups I and II were much more likely to visit than others in this age group.[4]

3 Stuart Davies, *By Popular Demand: A Strategic Analysis of the Market Potential for Museums and Galleries in the UK* (London: Museums and Galleries Commission) 1994, pp. 52-53.

4 Harland et al., *Arts in their View*, pp. 101-102.

The NFER report also showed that less than a quarter of young people (23%) participate actively and creatively in any area of the arts, although those that do so attach high value to these activities in their lives.[5] Two thirds (66%)

5 Ibid., p. 31.

said they wanted to take some arts activity further in the future, although visiting galleries, at 1%, featured much lower than the most popular future activity – drawing or painting – at 14%.[6] The young people interviewed identified the main obstacle to future arts participation as lack of time (16%), lack of money and equipment (12%), and the lack of local opportunities (10%).[7]

6 Ibid., pp. 205-07.

7 Ibid., p. 117.

Perhaps the most surprising result of the survey was that of those young people who highly approved of alternative arts, 84% felt that traditional arts were very important (less than 1% disapproved of alternative arts). At least amongst those who identified strongly with the arts (alternative or traditional) these distinctions no longer seem to be so significant. But these are only one group of young people – those for whom the arts are important.

It is necessary in any case to make a distinction between attitudes to these art forms on the one hand, and attitudes to institutions on the other. As a recent study by Sara Selwood noted, 'Many of the young people we surveyed seemed to have preconceived ideas about art galleries. They tended to think of these as quiet, grand and generally boring places with bog standard paintings! They also regarded them as part of the establishment.'[8]

Museums today are at least partly aware of the gap between youth cultures on the street – where values change almost moment by moment – and the cultures represented in permanent collections, given an almost eternal

8 S. Selwood, S. Clive and D. Irving, *An Enquiry into Young People and Art Galleries* (London: Art and Society) 1995, p. 77.

value by the institution in which they sit, however they are regarded by the wider public. There are many examples of the problems faced in trying to integrate youth culture within an educational context. A few years ago, for example, breakdance 'had flourished despite school bans and collapsed as soon as it was offered on a youth arts menu', according to one arts development officer.[9]

9 Nick Randell, in R. Ings, *Networking for the Nineties: A Youth Arts Seminar* (London: London Arts Board) 1994, p. 3.

Visitor data from the Victoria and Albert Museum gives an indication of the complexity of the relationship between young people and museums. Whilst young people are under-represented amongst users of museums in general, at the V&A 18-to 24-year-olds are 16% of the total audience, and 25-to 34-year-olds 19%. Further analysis shows that a majority of the young people who use the V&A are post-16 students, who account for 20% of all visitors – an extraordinarily high figure for a museum by any standards.[10] On the other hand, as only 2% of V&A visitors of all ages are South Asian, 1% Chinese, and almost none Afro-Caribbean, it is unlikely that the ethnic diversity of young people in post-16 education is reflected in the ethnic make-up of the young people using the V&A.[11]

10 Visitor Admission Data, Victoria and Albert Museum (unpublished) 1997; *V&A Visitor Surveys* (unpublished) various dates.

11 Jonathan Rutherford, 'Young Britain: Introduction', in *Soundings*, Issue 6, Summer 1997, p. 116.

The problem is compounded by the lack of a clear definition of 'young people'. The museum sector has developed sophisticated systems for classification of objects, but neither the MGC nor other cultural agencies have so far attempted a basic classification of audiences based on the nature of their engagement with cultural resources. A consequence of this

fundamental intellectual neglect (which in itself is a telling metaphor for the low priority many museums give to their audiences) is that there is not even a provisional or working definition of young people in use in the museum sector. When they do so at all, many museums use a variety of definitions based on age (for example 15 to 24 years, 18 to 24 years, 18 to 29 years, or even 15 to 34 years).

Whilst age categories provide a necessary reference point for the study of young people's engagement with museums, they tell us relatively little else of value. If the emphasis is shifted from 'young people' to 'youth', from age to lifestyle, then cultural identity becomes the focus for attention, and one which is more relevant to the activities of institutions whose purpose is cultural.

A conference organised by Centaur Marketing in 1995 asked the question 'Can the youth market be successfully targeted by socio-economic background?' The conclusion was that it could not; the diversity of young people defied coherent categories. In a context of fluidity in which identities are continually being redefined, it is much easier to target young people through the ingredients of their culture, and their connections to magazines and other media. Yet even here, as youth cultures become commodified, so too their authenticity and power are compromised.[12]

12 Ibid., pp. 113-14.

Some museums have been successful on some occasions at attracting young people and/or representing youth cultures, as this book

demonstrates. One might add here another example: 'Streetstyle' at the Victoria and Albert Museum, an exhibition in 1995 on the dress of youth tribes in the UK since World War Two. Young people were the largest audience for this exhibition. The galleries were packed with young people writing notes from the labels, sketching and discussing the exhibits. At first sight the exhibition appeared to present a renewal of contact between traditional museology and a new audience, but this would be an oversimplification. A significant proportion of the young people who flocked to the exhibition were a particular sub-set, that is, students. Some staff in the museum were concerned that the exhibition would be a Trojan Horse bringing with it less welcome aspects of youth culture, including illegal substances! In fact the occasion which caused greatest anxiety in this respect was the exhibition's official opening, when some of the older, and more affluent progenitors of youth and counter-cultures were amongst those present. Whilst no detailed survey was undertaken of those attending 'Streetstyle', it is clear that mainly well-educated young people were its biggest audience. Since 20% of the V&A's visitors are students anyway, the exhibition probably did more to make one of its current audiences visible, than to change its audience. This in itself was a very positive development for the V&A, and an achievement – but the nature of the achievement should be understood for what it was.

The difference between the affluent and educated young people on the one hand, and the economically and educationally excluded on the other, has never been wider. Jonathan Rutherford, in a recent issue of *Soundings*, has pointed out that 18-to 25-year-olds make up 14.7% of the electorate. In the 1992 election, 2.5 million of these did not vote, and in 1997 nearly one in five young people of this age group were not even on the electoral register. Sixty per cent of 15-to 24-year-olds have a disposable income of less than £50 per week. One half of teenage boys and one third of girls interviewed for a 1996 Home Office Report, *Young People and Crime*, had been involved in crime. By their mid-twenties, young women had grown out of this, only 4% admitting to committing a crime other than drug-taking, but the figure for young men of a similar age was 31%.[13] A range of economic and social developments, operating in combination with government policies, have resulted in the emergence of an economic, political and cultural division between a large minority of young people and the majority of the rest of the population, unlike in nature and extent anything that has been seen before in the UK. As Rutherford notes, this inequality follows fault lines of race and geographical location. And, one might add, there can be little doubt where the majority of museums stand in relation to this division.

Is the implication, then, that museums should in future become more representative of

13 Ibid., pp. 114-19.

youth cultures, and more relevant to young people? Stage more exhibitions which are generated and presented by young people aged 16 to 25, or 18 to 34, or whatever age is used to define youth? Establish projects for young people? Create a 'Young Board of Trustees', with the power to write some labels and select some exhibits? Use young contemporary artists and performers, and install contemporary digital media to interpret spaces and collections? Open the museum in the evenings, when many young people gather? Provide inexpensive, good quality refreshment and social facilities? Develop links with other local learning and social centres?

In the end, all these worthwhile, innovative, public-minded activities targeted at young people may not work, or may not work enough for young people, to justify the change. The absence of young people from museums is not in itself the 'problem' (if, indeed, it is accepted that there is a problem). Rather, it is a symptom – albeit the most conspicuous one – of something wrong with museums as we have them today. This is a cultural and philosophical matter, not a demographic one. It is something that affects every visitor, not just young people. To focus on young people alone is to miss the point. Young people, especially those from socio-economic groups IV and V, are missing from museums in disproportionate numbers not simply because they are young, but because when they were children they were not welcomed and engaged, because they now have limited financial resources, because museums do

not give them the chance to participate, because they are culturally alienated, and because their lives are not represented in museums. These are all factors which affect most other visitors or potential visitors as well as young people. So it is museums themselves, rather than their provision for young people, that would have to change. How many museums are able to achieve this?

One of the abiding myths of museums is that whilst they are culturally rich, the society around them is, in varying degrees, culturally impoverished. It is perceived that this is particularly true of those groups in society who do not visit museums and are therefore, by definition, particularly culturally deprived.

Underlying this myth are two powerful assumptions. One is that culture is a property of inanimate objects (particularly those we in museums have selected), and works by a process of radiation from these objects onto the humans who stand in front of them. Despite their pretensions to academic respectability, museums have never tested this hypothesis or developed any theoretical framework to support it and give it credibility. In opposition to this assumption there is an extensive body of learning research and theory which strongly suggests that culture works only through the actions and experiences of people. As the late Professor John Blacking wrote in 1990, 'Cultures are the experiments which human communities have devised at different times and in different places not only to get a material living, but above all to provide

14 John Blacking, 'Culture and the Arts', in Keith Swanwick (ed.) *The Arts and Education* (London: National Association for Education in the Arts) 1990, pp. 82 and 84.

15 In Dominic Strinati, *An Introduction to the Theories of Popular Culture* (London: Routledge) 1995, p. xviii.

16 Rutherford, 'Young Britain: Introduction', pp. 112-25.

a framework for making sense of profound emotions, institutionalising love and the joy of association, and finding new ways of extending the body.'[14]

Blacking makes clear his belief that culture exists only in performance, and his rejection of the idea that artists are the 'creators and bearers of cultural values'.[15] To assume culture is an intrinsic quality of inanimate objects thus represents a profound misunderstanding of its nature.

The second assumption about culture, deeply embedded in the thinking of many museums, is that the cultural practices of contemporary societies are not only peripheral to the cultural process, but are also of less value and significance than those of past societies (or rather of those groups and individuals represented in museums and selected by museums). The effect this has is both to lessen the status of contemporary cultural activity and, more specifically, to exclude contemporary popular culture (which Hebdige defined as 'a set of generally available artefacts: films, records, clothes, TV programmes, modes of transport, etc.').[16]

There are consequences that inevitably follow from such museological misconceptions; museums that hold them elevate dissociation, passivity, deference and exclusion over sociability, engagement, interchange and inclusion. Such museums impoverish themselves and their existing audiences as much as they impoverish those they exclude; they deprive themselves of the pleasures, skills,

desires, experiences, ideals and pluralism expressed through contemporary popular cultures, and of their regenerative power.

Jonathan Rutherford of Middlesex University has identified a tension in the UK in the ideology of New Labour between its aspirational languages of success and service to a cause, and the informality and openness to pleasure and desire of popular culture.[17] A similar tension exists between museums and popular culture.

17 Ibid.

How much of the cultural energy of the last fifty years of popular culture in the UK has been harnessed by museums? To what degree have museums nurtured, and been nurtured by, the arts of counter-cultures as well as those of the establishment? To what extent have they demonstrated that the arts, or the sciences, or the humanities, are ways of being as well as ways of owning? How far have they broadened their concept of excellence to embrace excellence of experience as well as excellence of product? In the regularity of the museum's logical systems and spaces, where is there room for the irregularity of rhythm, the anti-rationality, the complexity and the intuition that are also typical of our age? Can museums invest resources of space, staff and money in creativity, and give it a status equal to that which they presently bestow upon authenticity? So far, all of these questions must be answered mainly in the negative.

As stated here, it might seem that there is only one logical option open to museums – to embrace the practices and values of popular

cultures, including counter-cultures. Not necessarily. It is not just the myths of museological practice which stand in the way of such a development, but also some long-standing principles of museum work, which, it could be argued, define the very nature of a museum, the loss of which would destroy the foundations of museums and everything positive they contribute to society. These deserve consideration.

One principle is that of the permanency of collections and of each individual object they contain, once acquired. How can this principle be reconciled with the transience of the products of popular culture? Another is the role of museums as public spaces; their capacity to provide safe, comfortable, beautiful and welcoming environments for informed debate and expression of public feeling is one of their glories. Museums can be community centres in the broadest sense. If they are to perform such a public service, how far can they go in endorsing cultural values which conflict with the democratically-agreed norms of society? What should they do if (for example) some groups in society disregard the rights of others, or even break the law in pursuit of their own cultural practices (as representatives of both the establishment and some counter-establishment groups have done in recent years?) To what extent can inclusion and representation of the democratic consensus be reconciled?

This is not to argue against inclusion, but it is to note that it may not always provide an effective answer in a society such as ours, in which cultural divisions run deep. Museums may be forced to make choices. One choice is to provide common ground and shared public space, but to take this process only as far as consensus will allow. Another is to represent some groups – perhaps including young people who stand outside the mainstream – above others and be willing to lose some other audiences in consequence. (This is not such a shocking proposal; it is, after all, what many museums have done already in choosing to serve the affluent and better-educated, and adopting museological practices which suit those groups.) In the process, museums of this latter kind may need to abandon some currently accepted principles of their work, in order to welcome new audiences. We have already seen this process begin in another way in the United States, where artefacts have been returned to Native American groups for ritual use, rather than for preservation.

There is at present a plethora of grandiose projects declaring themselves to be 'museums of the future'. One thinks, for example, of the new Getty Centre in Los Angeles – an ace tea garden with quite a nice museum attached. Or of the Guggenheim in Bilbao, which wastes dazzling architecture by using it to house very traditional art museology. The future for museums does not lie with institutions such as these, but rather with responsive organisations working closely with their communities.

It is not clear at the moment how museums will reconcile the tensions in our society

between affluence and want, inclusion and exclusion, object and experience, permanency and transience, establishment and counter-culture. Which audiences are we here for? The age of the MGC – of functional analysis, of registration even if you neglect your public, of pious guidelines on collections care – is over.

The museum sector in the UK and the rest of the Western world has so far lacked a sharp-edged counter-culture of radical museology, in which some of our hallowed principles are subverted, but for some museums it may be the shape of things to come, and the sector as a whole may well be the better for its emergence.

Contributors

DAVID ANDERSON taught history in a comprehensive school before becoming Education Officer at the Royal Pavilion, Art Gallery and Museums, Brighton in 1979. He moved to become Head of Education at the National Maritime Museum, Greenwich, where he created two interactive history galleries, Armada Discovery and Bounty Discovery. Since 1990, he has been Head of Education at the Victoria and Albert Museum in London. His extensive publications include *A Common Wealth: Museums in the Learning Age* (Stationery Office Agencies, 1999), the second edition of his report for the Department for Culture, Media and Sport on museum education in the United Kingdom.

LEWIS BIGGS, Curator of Exhibitions at Tate Gallery Liverpool 1987-90, is currently Director of Tate Gallery Liverpool. He worked earlier at the Museum of Modern Art in Oxford; the Whitechapel Gallery in London; the Arnolfini Gallery in Bristol; and in the Fine Arts Department of the British Council. He is a member or Trustee of a large number of national and international visual arts and museums organisations.

EILEAN HOOPER-GREENHILL is Professor and Director of the Department of Museum Studies, University of Leicester. She is the author of *Museum and Gallery Education* (Leicester University Press, 1991), *Museums and the Shaping of Knowledge* (Routledge, 1992), *Museums and their Visitors* (Routledge, 1994) and *The Politics of Visual Culture: Museums, Pedagogy and Social Change* (2000).

TOBY JACKSON has been Head of Interpretation and Education at Tate Modern, London since 1999. He was formerly Head of Education at Tate Liverpool, where he established the innovative Outreach Programme and initiated Young Tate. He produced the Tate Gallery's first interactive CD and worked on a wide range of other important initiatives. Toby Jackson has served on the Visual Arts Panel at the Arts Council of England and was a member of the National Curriculum Art Working Group. He has lectured in Canada, Australia and America as well as throughout the UK.

ULLRICH KOCKEL is Professor of European Studies at the University of the West of England, Bristol, where he leads the European Social and Political Research Unit. His research interests include culture contact and conflict, culture and economy, and counter-cultural movements. His published books include *Borderline Cases: The Ethnic Frontiers of European Integration* (Liverpool University Press, 1999) and *Regional Culture and Economic Development: The Contribution of European Ethnology* (Ashgate, 2000).

GABY PORTER is a consultant for museums, arts and heritage organisations. Her consultancy spans interpretation, audience development and ICT, collections management, project and organisational development. Most recently, she worked at the National Museum of Photography, Film and Television, Bradford and the Museum of Science and Industry in Manchester. She has published extensively on gender and museums.

SARA SELWOOD is a Senior Fellow and Head of the Cultural Programme at the Policy Studies Institute in London. She edits the journal *Cultural Trends*, and she has contributed articles to other journals. Sara Selwood is author or co-author of *The Benefits of Public Art: the Polemics of Permanent Art in Public Places* (1995); *An Enquiry into Young People and Art Galleries* (1995); and *Culture as Commodity? The Economics of the Arts and Built Heritage in the UK*.